THE LAST
LYNCHING

in

NORTHERN
VIRGINIA

THE LAST
LYNCHING

—— *in* ——

NORTHERN
VIRGINIA

SEEKING TRUTH *at*
RATTLESNAKE MOUNTAIN

JIM HALL | Introduction by Claudine L. Ferrell, PhD

THE
History
PRESS

Published by The History Press
Charleston, SC
www.historypress.net

Copyright © 2016 James E. Hall
All rights reserved

First published 2016

Manufactured in the United States

ISBN 978.1.46713.565.8

Library of Congress Control Number: 2016936018

CONTENTS

INTRODUCTION

Ay, black was the man, and black was the deed,
But blacker by far was the lawless creed
Of those lawless men with their faces white
Who avenged the deed in the dead of night!
—Townsend Allen, "Columbia's Disgrace,"
Colored American Magazine *(August 1903)*

E ndless rows of cotton touched by the light fingers of a summer breeze
as the sun continues baking the hard earth. Dusty streets between newly
painted storefronts and windowless cabins with rough wood porches. Cool
water shimmering over mossy rocks and streambeds crossed just hours earlier
by laughing children. Moss-covered oak trees reaching to provide shade for a
weather-beaten shed protecting an old plow and a tired mule almost as old.

All and more were the sites of mob murders from the late 1800s to the mid-
1900s—as was, Jim Hall explained, an apple tree at the foot of Rattlesnake
Mountain in Fauquier County in Northern Virginia. Tens of thousands of
mob members killed—by rope, gun, fire, knife, fist and any other means at
their disposal—thousands of alleged violators of the law and of social order.
For three-quarters of a century, most members of the mob were white men
(and even women and children), and most of the victims were black men
(and even women and children). The alleged violations varied from murder,
arson and rape to speaking disrespectfully to a white man. Sometimes the
crime matched the statute books. Sometimes the offender received a trial,

and sometimes the trial provided a semblance of due process. All too often, the mob acted regardless of statute or court or fairness.

Through years of skillfully piecing together the puzzle of Shedrick Thompson's life and last hours, as well as white Virginians' views of themselves, Hall has found that Thompson was an apparently guilty man who died not by his own hand, as authorities ruled and the county wrote into its memory, or even as a result of a legal system merely going through the motions as it sought a predetermined punishment, but as a result of a "lawless creed" executed by "lawless men."

America's lynching record began well before Thompson's death in 1932, peaking in a decade of economic and social tensions, the 1890s, with about two hundred per year, mainly in the South but also scattered throughout much of the West and Midwest. Although presidents spoke unsupported words to unlistening southern states, lynching—mob murder—slowly declined to double digits in the first third of the twentieth century and then to single digits in the mid-1930s. Its origins unclear, the decline was likely spurred by a variety of factors, including southerners' concern about their state's image and the reach of urbanization and "civilization" into no longer remote areas disconnected from the influence and response of the outside world. In the 1950s, lynchings disappeared from official tabulations, although they are not yet gone, just relabeled as "civil rights" violations and, as many long urged, as "mere murder." Those who insisted on shining the light on mobs— most notably the Tuskegee Institute, the *Chicago Tribune* and the National Association for the Advancement of Colored People (NAACP)—ended their haunting accounting task, and black newspapers no longer printed end-of-year chronologies of lynchings alongside lists of the nation's notable cultural, political and diplomatic achievements and milestones.

By the end of the twentieth century, historians had joined sociologists in the investigation of the mysteries of mob murder. Why did it happen in one county but not in neighboring ones? Why did mobs target respected and successful blacks, not just the allegedly uncontrollable lower-class "brute"? Why were men taken from jail and killed after being convicted and sentenced to certain death by a white legal system? Why were blacks killed even when they were known to have had nothing to do with the alleged offense that triggered the mob's formation? Some of the answers to these questions are part of the Shedrick Thompson story.

According to Tuskegee Institute's numbers, Virginia's one hundred mob victims included eighty-six African Americans. The state's murder statutes and its anti-lynching statute, the latter enacted in 1928, were likely of some

use to many blacks when they were accused of acts that threatened white control and security. While white Virginians acted to protect their social order and their race when the law was either too slow, too flexible or too mild in dealing with black defendants, they also relied on their belief in their civilized commitment to justice and fairness and as states to the South—particularly Mississippi, with almost six hundred lynchings, more than five hundred African Americans—resorted to vigilante justice at a stunning pace in the post-Reconstruction decades.

For Jim Hall, piecing together what happened to Henry and Mamie Baxley on a hot July night in 1932 and to Shedrick Thompson soon after only four miles away means clarifying two attacks: one committed on a sleeping husband and wife and one on a man who never had his day in court. And for his readers—lucky to have found such a dedicated researcher and compelling writer—it means one more step in clarifying the history of race, justice and community in American history.

CLAUDINE L. FERRELL is a professor of history at the University of Mary Washington in Fredericksburg, Virginia. She has taught there since 1984. She holds a PhD from Rice University, where her doctoral research focused on lynching in the South. She is also the author of *Reconstruction* (2003) and *The Abolitionist Movement* (2005).

ACKNOWLEDGEMENTS

This book would not have been possible without the cooperation of the people of Fauquier County. Many were hesitant to talk about what happened there in 1932. Several questioned why I would bring up so unpleasant a topic, and they did not want to be associated with the project. It was as if the attack on the Baxleys and the death of Shedrick Thompson had occurred yesterday, not eighty-four years ago, so fresh were the feelings that surrounded the event. Even so, many residents wanted to talk about what happened and agreed to share their memories, photos, records and time. To them, I say thank you very much. These included Alphonso Washington, Sylvia Gaskins, the late Melvin Poe, Jeff Urbanski, Henry Green, Reverend Lindsay Green, Reverend William Gibbs, Reverend Allen Baltimore, Dorothy Showers, Mary and Barbara Herrell, Sam Poles, Chaz Green, Carol Scott, Doug Hume, Hubie Gilkey and Michel Heitstuman.

Of all the people in Fauquier, no one was more vital to the completion of this story than Henry Baxley Jr., who was an infant at Edenhurst with his parents the night they were attacked. The attack was a painful family memory and little discussed. Even so, Mr. Baxley was available on several occasions to talk about the incident, to visit locations important to the story and to introduce me to others. His knowledge, patience and generosity were unmatched. My copy of his self-published family history, *The Cove Remembered*, is filled with marginal notes, underlined sentences and highlighted passages. One paragraph at the start of the book gives insight into the kind of man Mr. Baxley is. He wrote, "There is no

copyright for this book. The author would be tickled to death to have any or all of it copied to any extent."

I am also grateful for the support of my former colleagues at the *Free Lance-Star* newspaper. These include Brian Baer, Kristin Davis, Rusty Dennen, Cathy Dyson, Bill Freehling, Edie Gross, Rob Hedelt, David Lyne, Nancy Moore, Susan Morgan, Howard Owen, Karen Owen, Suzanne Rossi, Neva Trenis and Lee Woolf. They read early versions of the story, shared their knowledge, helped in my research, showed interest in the project over many months and encouraged me when I encountered setbacks.

I feel lucky to have received valuable help from Claudine Ferrell at the University of Mary Washington; Peter Wallenstein at Virginia Tech; Art Tracy, retired from the University of Mary Washington; and William Freehling, retired from the University of Virginia. These scholars responded to my queries, read early drafts of the book and offered encouragement and advice. What amazed me was that I was a stranger to all but Tracy. Ferrell offered suggestions about the structure of the book and wrote the foreword.

Endless thanks also go to Teresa Reynolds at the Fauquier History Museum at the Old Jail; Karen White at the Afro-American Historical Association of Fauquier County; Jack Bales, reference and humanities librarian at the University of Mary Washington; and the librarians at the Fauquier County Public Library, the Prince William Public Library System, the Central Rappahannock Regional Library and the Albert and Shirley Small Special Collections Library at the University of Virginia. Historians John Toler, Erik Nelson and Robert Dalessandro gave generously of their time and knowledge, as did Roger Engels, editor Laura Mathews, author Paul Metzger and former newspaper publisher Bo Jones. The suggestions offered by Dr. Wayland Marks, a Fredericksburg geriatrician, after he read an early draft were more helpful than he realizes.

It's also no exaggeration to say that *The Last Lynching in Northern Virginia* wouldn't be the book it is without the efforts of Tom Davenport and his colleagues Shawn Nicholls and Dylan Nicholls. Tom is a resident of Fauquier County, an award-winning filmmaker and founder of Folkstreams, an online collection of documentary films. Tom was long interested in the Thompson case and contacted me in 2013 about working together. The result was a collaboration that continues to this day. On countless occasions, Tom, Shawn, Dylan and I formed a caravan, traveling the roads of Fauquier from one filmed interview to the next. I look forward to seeing Tom's film about the Thompson case later this year.

I also feel lucky to have had the support of my family, especially my brothers Doug Hall and Bernie Hall, who were early readers of the manuscript. As I told them, I wish our parents were still alive so I could share this work with them.

And finally, my fiancée, Laura Moyer, deserves far more thanks than I can convey here. She listened patiently to my ramblings, offered countless bits of advice and read these pages as often and as carefully as I did. It would be impossible to count all the improvements that she suggested or measure the value of her support. Thank you, Laura.

Fauquier County, Virginia. *Courtesy of Fauquier County Department of Economic Development.*

A body had been found. It hung from an apple tree at the foot of Rattlesnake Mountain. By the time Deputy W.W. Pearson got there, a crowd had gathered—more than 150 people. Someone set fire to the body, and Pearson tried to beat back the flames with his new hat. Then a man punched a pistol in his ribs. "Get back," the man said. "Let it burn."

Chapter 1

THE ATTACK AT EDENHURST

Henry and Mamie Baxley were asleep in their upstairs bedroom when Shedrick Thompson attacked them. Their two-year-old son, Henry Jr., was sleeping in the adjoining bedroom. Thompson knew the Baxleys and Edenhurst, their home. He and his wife, Ruth, lived next door in a tenant house. He had worked as a farmhand for Henry and Henry's father, and Ruth was their cook. He moved confidently in the dark, entering the house through the back door into the kitchen, where he picked up a stick of stove wood. It was about ten o'clock on a Sunday night, unbearably hot, even for July in rural Virginia.

Thompson crossed the wooden floor of the foyer and then crept upstairs to the bedroom. Henry must have heard something because he was out of bed when Thompson reached him. Thompson was on him quickly, using the stick as a club. The two struggled in the dark, amid the sounds of confusion and pain. Thompson hit Henry on the arm and head and finally knocked him unconscious to the bedroom floor.

Thompson grabbed Mamie and pulled her from the bed. He dragged her past her downed husband, out of the bedroom and down the stairs. Together, the two stumbled through the door, across the porch and into the moonlit night. The date was July 17, 1932, in Fauquier County, Virginia. Thompson was black, thirty-nine and the Baxleys' employee. They were white, landed and, as one newspaper said later, "one of the most popular young couples in the county."

Inside the home, only silence followed the shouts and groans of the attack. Thompson and Mamie were gone, and Henry was unconscious. Henry Jr.

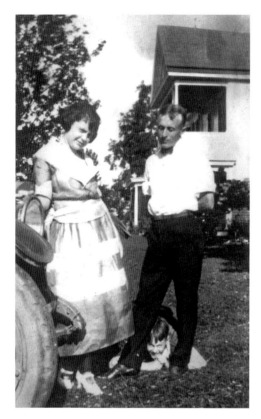

Left: Mamie and Henry Baxley. *Courtesy of Tom Davenport.*

Below: Edenhurst. *Author's collection.*

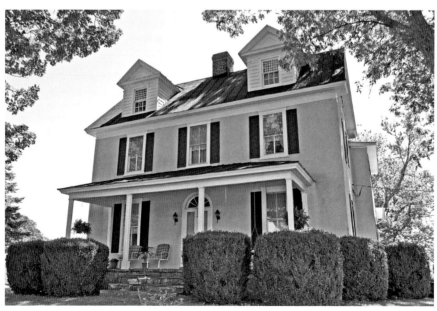

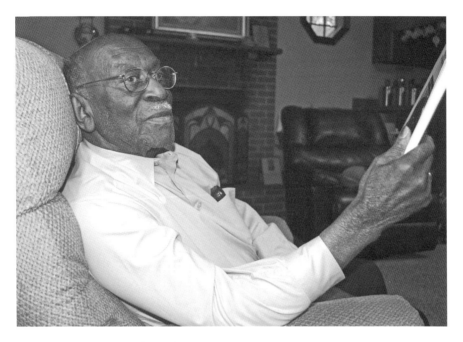

Alphonso Washington. *Author's collection.*

slept through the attack, unaware that his father was injured and his mother was missing. Whatever fury drove Thompson to attack the Baxleys that night did not involve their child.

Henry Sr. regained consciousness to find himself sitting by his son's bed. He said later that he had only the vaguest recollection of covering his head with his arms to protect himself against Thompson's blows. He called for his wife but got no answer. His head and arms were swollen and painful, but he moved quickly through the house, searching each room. Downstairs, the front door stood open. Henry peered into the darkness, the empty pastures and stillness. Nothing. He scooped up Henry Jr. and hurried outside to his pickup, an old Reo. It was after 3:00 a.m. as he drove to the main road and then south, past Hume, to the Cove, Mamie's childhood home.[1]

Alphonso Washington was a teenager then and had been working as a "houseboy" for Mamie's family at the Cove for about a month. He saw Henry pull up the driveway, park his truck and, with his son in his arms, run into the house. Henry told his in-laws of the attack and Mamie's abduction. He was "bleeding freely" and still dazed, one newspaper reported, and the family was surprised that he had been able to drive.[2] He said he thought Thompson had shot him. But his in-laws examined him and said instead

Buck Mountain, as seen from the Edenhurst driveway. *Author's collection.*

that it looked like he had been beaten. Washington, now 102 years old, is a retired preacher, living in Culpeper, Virginia. In an interview in 2014, he recalled what it was like when Henry arrived at the Cove and told of the attack. "He didn't know nothing about where [Mamie] was," he said. "He didn't know nothing."[3]

The abduction from her bedroom was just the beginning of Mamie's nightmare. Thompson grabbed her under the arm, pushing, dragging, almost carrying her down the hill and the dirt driveway outside her home. They made an unlikely pair as they hurried west through the night. He was six feet, 190 pounds and labor-strong; she was tiny, so small that she had to use a pillow to reach the pedals when she drove.

At the end of the driveway, they crossed Route 688, now known as Leeds Manor Road, and entered the rocky pasture on the other side. They had not gone far into the field when a car approached. It was Lucian Moss on his way home from Hume, where he had been playing bridge. His window was down, and he was singing. Mamie knew Moss from their choir at Leeds Episcopal Church and recognized his beautiful voice. She tried to pull away from Thompson; surely Moss would see them and stop. But the car did not

slow, and the headlights moved away. If Mamie had any hopes of rescue, they faded then, leaving her with the fear of what was to come, the possibility that she might never see her husband and child again.[4]

Thompson pulled her through the pasture, across a creek and past the thickets of briars and redbuds. The land was too rugged for crops. Instead, the Baxleys grazed cattle there and produced apples. Everyone knew the place as Locust Shoots. After a hundred yards, they reached the foot of Buck Mountain, out of sight of the road. Mamie was scared and sore from Thompson's rough handling. But she told her family later that of all the injuries she suffered that night, among the worst were the cuts to her bare feet from the rocks and briars.

No one but Mamie knows how long she was Thompson's prisoner. No one knows what, if anything, he said to her. Was this some sort of drunken payback for something he thought she had done? Was he angry at her husband? Two days later, when Stanley Woolf, sheriff of Fauquier County, prepared a wanted poster for Thompson, he used technical language to describe the incident as a "criminal assault on a white woman, a capital offense." The members of a Fauquier County grand jury were less delicate. They said Thompson raped her, a charge she later confirmed.[5]

Thompson also knocked Mamie unconscious and pulled the rings from her finger—her diamond white gold engagement ring and her wedding ring, white gold with orange blossom engraving. Carved inside the wedding ring were her and her husband's initials and their wedding date: "H.L.B.—M.M.Y.—6-2-23." She and Henry had just celebrated their ninth anniversary. Now, like her husband, she had been beaten senseless and left for dead.

Mamie came to at about seven o'clock that morning. She stumbled north through the field to the dirt road, where she collapsed in the front yard of the Jackson house. James and Georgie Jackson, a black couple, lived in a tenant house owned by the Baxleys; he worked for Mamie's father-in-law. James picked up Mamie in the front yard and carried her into the house, where Georgie tended her bleeding wounds. Groups of men were already searching for Mamie, and Jackson found one group and took them back to his home. Soon, family members were there and drove Mamie and Henry to Fauquier County Hospital in Warrenton.

The Baxleys were a farm family and apple growers. Henry was a protégé of former governor Harry F. Byrd and chairman of the county Democratic Party. Mamie was the granddaughter of one of the largest and wealthiest landowners in the region and the stepdaughter of the chairman of the county

BRUTALLY CLUBBED WHILE ASLEEP IN BED

Mr. and Mrs. Henry Baxley Beaten Into Unconsciousness While Asleep Early Monday Morn.

Northern Fauquier County was profoundly stirred on Monday when news rapidly spread that Mr. and Mrs. Henry Baxley, well-known residents of the Markham-Hume community had been brutally assaulted in bed by a colored man in the early hours of the morning.

The crime first became known when Mr. Baxley appeared, with his little child, at "Morven," the home of his father, J. Leroy Baxley, at about four o'clock Monday morning, and announced that he believed that he had been shot. Though he was bleeding freely, an examination showed that his injuries were due to blows from a blunt instrument.

When Mr. Baxley first became conscious that anything had befallen him, he discovered himself sitting by the bed of his child in a room adjoining that of himself and wife. He had only a vague consciousness of having covered his head with his arms to protect himself from a blow. His wife was

Thompson's attack on the Baxleys was front-page news in many newspapers, including the *Strasburg News*. *Author's collection.*

school board. Thompson, too, was from a longtime Virginia family. He was an army veteran who'd served in France during World War I. Yet now he was traveling a path from which he could not return. He had sneaked into the Baxley home, assaulted Henry and abducted, raped and beaten Mamie. He was doomed.

Thompson fled north toward the mountains where he grew up. As he crashed through thistle and goldenrod, he must have known that he was running for his life. Rape was a capital offense in Virginia in 1932, punishable by electrocution. Two months before Thompson assaulted the Baxleys, the state executed Sam Pannell, an eighteen-year-old black man from Halifax County, who was charged in January 1932 with the rape of a white woman. A Halifax County Circuit Court jury deliberated for eight minutes before sentencing him to death.[6] Throughout the state, the rape of a white woman by a black man was punished harshly. From 1868 to 1932, Virginia executed fifty-five people for rape and attempted rape—all of them were black.[7]

The search for Thompson was the largest in the county's history, lasting for weeks and involving law enforcement and hundreds of volunteers. Day after day, groups of armed men, some organized by the sheriff and others self-assigned, combed the mountain paths. Some of these men invaded the homes of local black residents, accusing them of hiding Thompson in their

cellars or behind cabin doors. Suspected sightings of the fugitive came from as far away as Culpeper, thirty miles to the south. Yet despite these efforts, the searchers found nothing and eventually returned to their everyday lives.

Then, nearly two months after the assault, a farmhand checking a fence line at the foot of Rattlesnake Mountain, a few miles from the Baxley house, found Thompson's body hanging from an apple tree. Word spread and a crowd gathered. Despite the presence of a deputy sheriff, members of the mob set fire to the body, destroying everything but the skull. They also removed Thompson's teeth as souvenirs. The county coroner ruled that night that Thompson had climbed into the tree, attached a rope to his neck and jumped out. A few days later, a county grand jury confirmed his verdict. In the community and elsewhere, the two rulings seemed hasty, part of a clumsy coverup. Soon local newspapers reported the details of what they said was a lynching, and national civil rights groups added Thompson's name to their lists of lynch victims. But former governor Harry F. Byrd, among others, argued for suicide, and with no trial and no public explanation, the official verdict stood.

And so began the Depression-era mystery of Shedrick Thompson. Thompson had worked for the Baxleys for more than fifteen years. He, his wife and his stepson lived next door to them. The two families were of separate worlds: one black, the other white; one poor, the other rich. They were neighbors, perhaps even neighborly. Yet Thompson had tried to kill them. Why? And what happened to him on Rattlesnake Mountain? The county coroner and a county grand jury ruled his death a suicide, the final act of a desperate fugitive. Because of this, some historians do not include his case among Virginia's lynchings. To them, lynching in Virginia ended years earlier with passage of a state anti-lynching law. But the evidence points to another conclusion: murder. Thompson did not commit suicide on Rattlesnake Mountain. He was captured and killed by a posse of his neighbors, the victim of Virginia's last lynching.

Chapter 2

THE HUNT FOR THOMPSON

The book of Daniel in the Old Testament tells the story of Shadrach, Meshach and Abednego, three devout young Jews captured by the Babylonians and sentenced to die by fire when they would not worship the Babylonian god. The three were spared when an angel of God delivered them from the flames. For Thompson, namesake of the biblical Shadrach, there was no divine intervention, no angel sent from heaven to save him. He was on his own.

Searchers suspected that Thompson would flee northwest from Locust Shoots, where he abandoned Mamie Baxley, across Buck Mountain, toward his family's home on Rattlesnake Mountain, three miles away. There, in the notch called Africa Mountain, lived the Rectors, Blues, Fords, Pendletons, Johnsons and Thompsons. The community dated to the 1850s, and sixty black families sent their children to its one-room Cherry Hill School.[8]

This was a rugged and remote corner of Fauquier, little touched by logging or development. Thompson fled through dense stands of oak, locust, poplar and sycamore. He crossed fallen trees and stone fences, gaining elevation one minute, descending into rocky hollows the next. But these many obstacles also offered sanctuary. He could hide in the old-growth forests or beside pastures with their grazing sheep. The temperature that day reached ninety once again. The region and the nation had suffered through a terrible heat wave that had ruined crops and killed livestock. "It might not be getting any hotter, but one thing is sure and certain, it is not getting one bit cooler," the local newspaper noted. "A nice cool shower, with a cooling breeze following,

Jim Hall

www.arcadiapublishing.com
jehall171@gmail.com
(540) 424-8601

A farm outside Warrenton, Virginia, 1940. *Courtesy of Library of Congress.*

would help a lot." Still, Thompson had water on the mountain from natural springs and slow-moving creeks like Fiery Run or Buck Run.[9]

Fauquier was then, and still is, one of Virginia's largest and most beautiful counties. Founded in 1759, it is today among the outer circle of localities surrounding Washington, forty-five miles southwest of the capital. As a result, its landscape is now part rural and part suburban. The county roads are still tree-lined and speckled by the morning sun. The rocky pastures and fields of tasseled corn are surrounded by three-board fences. The crossroad villages still feature country stores, post offices and an abundance of churches. "One way or another, you are going to hear the word of God," observed Alphonso Washington about the village of Hume.[10] But the county is also home to

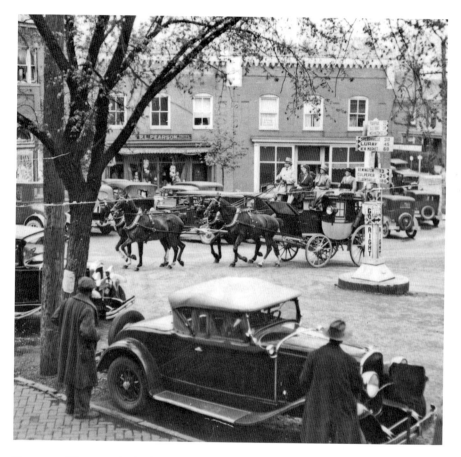

Downtown Warrenton in the late 1920s/early 1930s. *Courtesy of Fauquier Historical Society.*

large-lot subdivisions, driveways flanked by stone gateposts and wingwalls and more than two dozen commercial wineries. The photo gallery on the county's official website reflects both the past and present, with images of historic buildings, red-coated fox hunters and mountain vistas.

Some observers foresaw Fauquier's development. Writing in 1955, Jean Gottman, a French geographer at the Institute for Advanced Study at Princeton, visited Fauquier and wrote of its natural beauty, mild climate and "temperance of character." He added, "The proximity to Washington makes this an impressive and restful setting."[11] From then until now, Fauquier's population has more than doubled and now exceeds 67,500.

In a sense, Fauquier is two counties divided by geology, climate and land use. Its shape resembles a tent peg, left-leaning and wider at the top than the bottom. The northern end is mountain rock and steep foothills, with natural

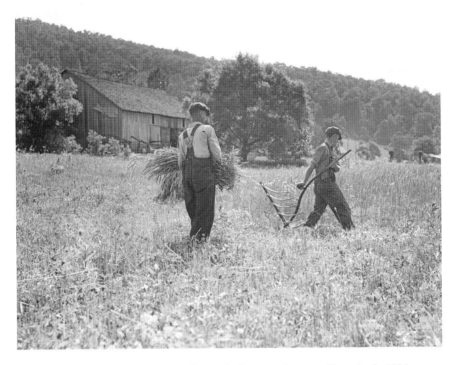

Men cradle wheat at a farm in Rappahannock County, adjacent to Fauquier, in 1936.
Courtesy of Library of Congress.

passes that served as the way west for settlers and became the roads that
helped define the region. The southern end is part of Virginia's Piedmont,
pastoral and picturesque.

Warrenton, the county seat, lies at the center of the county, a crossroads
town from colonial times. On a hill at one end of Main Street is the 1890
courthouse, an imposing, temple-like building of stuccoed brick and domed
roof. Clustered around the courthouse are shops, county offices and law
practices. Then come the tree-lined neighborhoods with landscaped lawns
and wrought-iron fences. By one account, the town features "one of the most
impressive collections of 19th century architecture in Northern Virginia."[12]
Yet it was here, under the steps of the courthouse, that Thompson's remains
finally came to rest.

In the 1930s, Fauquier resembled the land that the early explorers found
in the seventeenth century, with its "flowery meads," "luxurious herbage"
and "numerous herds of red deer."[13] At the time of Thompson's attack on
the Baxleys, the county was largely rural, with more than 150,000 apple

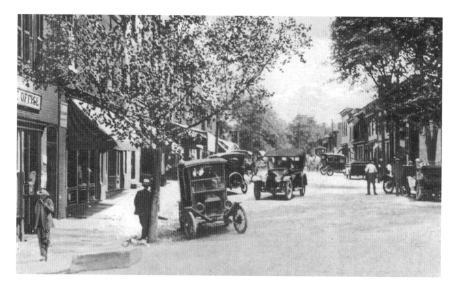

Main Street in downtown Warrenton, early 1920s. *Courtesy of Fauquier Historical Society.*

trees in its orchards and more farm workers than all other occupations combined. It counted barely twenty-one thousand residents, about one-third of them black. The population had been declining since the turn of the century. In fact, more people lived in Fauquier in 1830 than in 1930.[14] Still, in Warrenton, a visitor could find bath towels for ten cents at Cornblatt's Department Store or see *Wild Horse*, a Hoot Gibson western, at Pitts' movie theater.[15]

In the north end of the county, where the search for Thompson took place, the mountains stand 2,100 feet at their highest, a preview of the Blue Ridge Mountains, twenty miles to the west. Then, as now, the farms at the base of these hills were smaller than those in other parts of the county, at a higher elevation and with a shorter growing season. These were hill farms on hard land, where the forsythia and daffodils were slow to arrive each spring. The next mountain north of the Rattlesnake seemed an apt description for the region. It's called Hardscrabble.

The terrain was a perfect place for a man to hide, especially one like Thompson, who knew every stream, every rocky ledge. But the mountains were a cage, with no way out except the roads that circled them. Soon those roads were filled with people, dozens of armed men, in cars, on horses and on foot, traipsing through Moss Hollow and up Pigeon Perch Mountain. News of the attack spread quickly, person to person, neighbor to neighbor, since few residents had any other way of communicating. Barely one in four

Posses hunted Thompson along what is today Moss Hollow Road in the shadow of Buck Mountain. *Author's collection.*

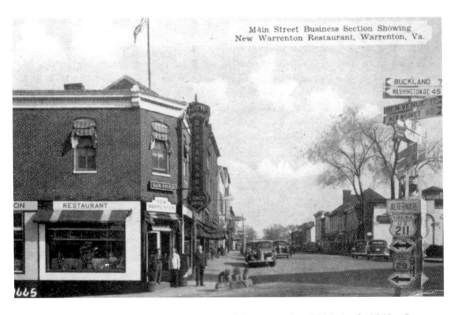

The New Warrenton Restaurant in downtown Warrenton, late 1930s/early 1940s. *Courtesy of Fauquier Historical Society.*

households had a telephone, and only one in six had a radio. Electricity was available in urban areas in 1932, but it would be years before it reached the rural corners, such as northern Fauquier. Autos were increasingly popular, but they were expensive, and one-third of Fauquier families did not own one.[16] Hickman & Hutchison, an auto dealer in Warrenton, sold new Chevrolets for $445, but that was more than a year's wages for the typical farm worker.[17]

People reacted to news of the attack on the Baxleys with anger and alarm. Within hours, self-appointed posses, consisting of at least forty men, headed toward the villages of Hume and Markham to join the search. Fresh recruits arrived later that evening from nearby Marshall, Warrenton and Delaplane, bringing the total number of searchers to several hundred. The men were told that Thompson was armed and to take no chances if they spotted him. The massive reaction, with men on horseback scouring the hills and hollows, reminded Alphonso Washington of a county-wide fox hunt. One local newspaper said the search was conducted with "vigor and completeness." Another noted, "Practically all the men of the community have been up in arms, and every mountain path has been watched on the supposition that

The men who sought Thompson came from Delaplane and other small communities within Fauquier. *Courtesy of Library of Congress.*

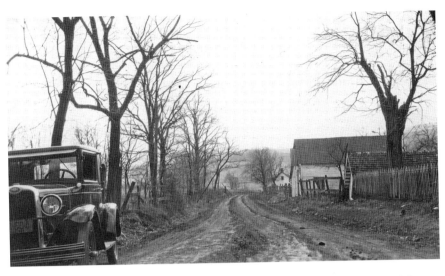

The road near Paris in the eastern part of the county was typical of Fauquier's roads in 1930. *Courtesy of Library of Virginia.*

he is still hiding and must come out for food." A third reported, "Northern Fauquier County was profoundly stirred."[18]

The road from the small community of Hitch, now known as Fiery Run Lane, was dirt, one lane and so narrow that when two cars met, one had to pull to the side so the other could pass. Visitors were rare, and when one did show, the children would yell, "Car coming!" so that no one would miss it. Yet with Thompson at large, it was lined with cars, all empty. Their drivers were in the mountains, searching.

Sheriff Stanley Woolf, as the county's chief law enforcement officer, took charge of the massive hunt. He asked the state police and neighboring sheriff's departments to watch the roads and check the freight trains that passed through the area. He also set up police camps in the mountains. Guy Jackson, a friend of Thompson's and a resident of Africa Mountain, recalled that deputies with hunting dogs spent the night at the spring near his house, watching for Thompson. "I didn't know they were there," he told students from the University of Virginia who interviewed him for a class project in 1973. "I was dead asleep."[19] Woolf also summoned a pack of tracking bloodhounds from the Virginia State Farm, a state prison in Goochland County. The dogs came to Fauquier twice, two days after the attack and again later that week, but never picked up a trail.[20]

By then, Woolf had been Fauquier's sheriff for eighteen years. He was tall and lean, with glasses, a bald head and big ears. In his fedora,

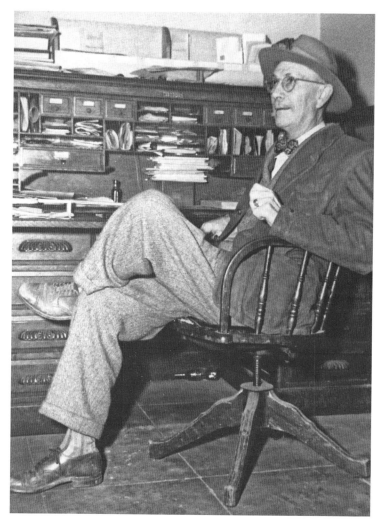

Sheriff Stanley Woolf. *Courtesy of Fauquier County Sheriff's Office.*

sport coat and bow tie, he looked more like a bank clerk than a southern sheriff. Yet he was a son of Francis Marion Woolf, who rode with the "Gray Ghost," the legendary Colonel John Singleton Mosby, and his Rangers during the Civil War. And he had a reputation as an effective sheriff. "If he went into a place and there was some little fracas, after he fired his pistol a few times, that settled the argument," said George Thompson, a lifelong resident of the county whose father was president of the local Marshall National Bank.[21]

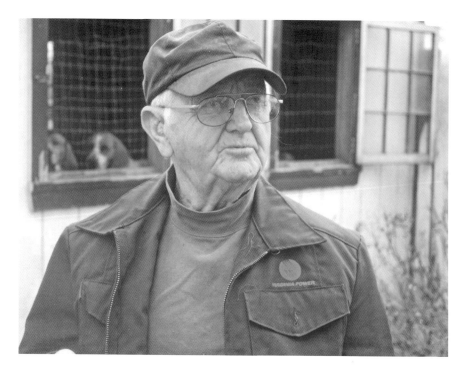

Melvin Poe. *Author's collection.*

Woolf organized formal search parties of armed volunteers, assigned to one section of woods and then another. Melvin Poe was eleven at the time of the attack and remembers watching a posse gather along Moss Hollow Road and step off together, as if on a game drive, trying to maintain their line.[22] Poe later became a professional huntsman and foxhound breeder. He lived in Hume, near where he grew up, until his death at ninety-four in September 2014.

But many of the men in the area did not wait for Woolf's direction. They convened their own search parties and hunted Thompson. In this way, they fit a pattern described by W. Fitzhugh Brundage in his study of Virginia lynchings: "Southern posses usually formed immediately after the discovery of a crime," he wrote. Sometimes they were legally deputized, but more often they were "spontaneous gatherings comprised of neighbors, relatives, or witnesses to a crime." They "straddled a very thin line between being a legal and extralegal arm of the law," he wrote.[23] The men hunting Thompson were mostly local farmers, mountain men, independent and self-sufficient. They, too, were the descendants of those who rode with Colonel Mosby or those who housed and fed his soldiers. Their ancestors were residents of

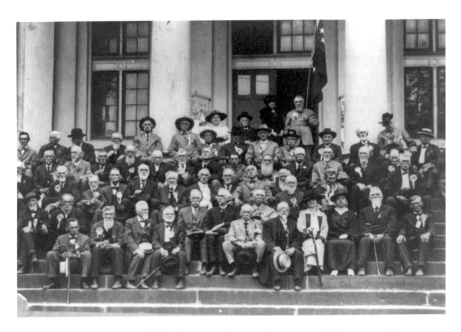

A reunion of Colonel John Mosby's men on the courthouse steps in downtown Warrenton, 1920–30. *Courtesy of Library of Congress.*

what was once one of Virginia's most ardent slaveholding counties. In 1790, about one-third of Fauquier's residents were slaves. By 1860, before slavery ended, Fauquier had more slaves than white people, the ninth-largest slave population in Virginia.[24]

These searchers also were the descendants and neighbors of those who founded the Free State. Many states have mythical sections within them dubbed "Free States," peopled by the stubborn and self-reliant. In Virginia, the Free State was in northern Fauquier. Legend had it that Fauquier's Free State dates to colonial times and to the mercenary Hessian soldiers captured by George Washington at the Battle of Trenton. More than one thousand Hessians were freed after the war, but some chose not to return to Germany. Instead, they found their way to Fauquier, where they settled in the shadow of the Blue Ridge. The land they chose was sparsely settled, with no apparent owner, part of a massive grant of thousands of acres made by King Charles II of England in the 1600s. They squatted in its remote hollows, refusing to pay taxes or rents.[25]

Today, visitors looking for the Free State will be told to go east from Thumb Run in the northern part of the county, then north from the village of Orlean along the tar road to Marshall and then back toward the mountains.

FAUQUIER POSSE HUNTS NEGRO ALLEGED TO HAVE ATTACKED MAN AND WIFE

CURTIS LAWYER MOVES TO SET ASIDE VERDICT

Charges Prosecutor Was In Court Contempt For Shadowing Trial Jury.

(By the Associated Press.)

FLEMINGTON, N. J., July 19—Lloyd Fisher, attorney, announced today he would apply immediately for an order to show cause why the verdict of guilty against John Hughes Curtis, who was convicted of hindering capture of the kidnappers of the Lindbergh baby, should not be set aside.

He said he would charge in his application that Prosecutor Anthony M. Hauck had been guilty of contempt in permitting members of the jury to be followed by detectives. Curtis, who was sentenced to a year in prison and a fine of $1,000, was released on

Shadric Thompson Believed Hiding In The Mountains After Assault on Mr. and Mrs. Henry Baxley.

BOTH BEATEN WHILE IN BED

Blows From Hand of Negro Knocks Both Parties Into Insensibility—Mr. Baxley Suffered Fractured Arm, While Wife Is Badly Lacerated About The Head —Victims of Attack Are Well-Known Citizens.

Special To The Star

The search for Thompson was chronicled in the *Winchester Evening Star* and other papers. *Author's collection.*

Yet locals know better, that the Free State is like Zion, a mythical kingdom with no fixed boundaries and no political sanction. It is "down the road from here," no matter where you are along the road. It's a state of mind, a style of life, that values hard work and scorns refinements. Free Staters are stout and proud, "fist-and-skull" fighters, not "gun-and-pistol" men. And it was this perceived freedom from civic responsibility that infused the men who hunted Thompson. They were the law.

For black people in Fauquier, like those throughout Virginia and the South, this was a difficult time, a time of Jim Crow restrictions, when they were subjected to systematic, statewide campaigns of segregation, discrimination and disenfranchisement. African Americans reacted by moving away from the South in great numbers. Fauquier's went to Washington, Baltimore and other cities, seeking jobs, safety and greater freedom. Between 1900 and 1930, the county's black population declined by 25 percent, or two thousand people. Fauquier's white residents also sought opportunities elsewhere, but not to the extent that black residents did.[26]

And so the men who hunted Thompson abandoned their chores and took up the search. They acted as if by instinct. None of them had spoken to Mamie, who was hospitalized after the attack, or to her husband, who remained with her. But they believed what they were told. To them, Thompson was guilty, and they wanted to send a message to him and to all black people that violating a white woman would not be tolerated. As Brundage noted in his study of Virginia lynchings, a sexual attack on a woman was seen as one of the most serious types of crime, "an offense of such gravity that it demanded the fiercest retaliation."[27] Fauquier had a functioning legal system, but Thompson's posse was impatient and disdainful of it. Their beliefs were validated by what happened later, when neither the sheriff nor the commonwealth's attorney nor the grand jury accused anyone of murdering Thompson or destroying his body. To these men, the law was careful, impersonal and based in Warrenton, twenty-five miles away. Thompson's attack was a local problem that called for community action, immediate and brutal. Or as the country song says, "A man had to answer for the wicked that he done."[28]

The men gathered at places like the Cash and Carry, Alex Green's store in Markham. Henry Green, Alex's younger brother and a lifelong resident of Fauquier, was twelve at the time. He remembered that one group of vigilantes almost shot a cow in the woods. He also recalled the line of guns on the porch of the store and hunting parties inside, talking about what had happened and what they would do if they caught Thompson. "What I

Above: The Cash and Carry was a gathering place for the men who hunted Shedrick Thompson. *Courtesy of Tom Davenport.*

Right: Henry Green. *Author's collection.*

remember was the excitement people had," he said. Green said he did not know what the word *rape* meant and badgered his brother for an explanation. Finally, Alex told him that Mamie had been hit over the head with a rake. That satisfied him.[29]

A possible sighting came on the afternoon of the attack when Eugene Campbell, a resident of Winchester, forty miles away, told authorities that he found a black man on his mountain property, sleeping beneath a tree. The man's gun was leaning against the tree. The man told Campbell that he stopped to rest while hunting groundhogs. But the man was gone when Frederick County police arrived. Another time, Thompson was said to be hiding in the woods near Culpeper, but that rumor was false. A man thought to be the fugitive was arrested in Harrisonburg, but it was not Thompson. And in Sperryville, about thirty miles away, Emory Pullen told police that a stranger matching Thompson's description approached him while he was cutting wood and asked directions to the Blue Ridge Mountains and Rileyville. Sheriff Woolf went to Rileyville and summoned the tracking dogs, but they could not find the man. Back in Fauquier, S.B. Moss reported that someone stole a cooked ham that was cooling on the porch of his mountain home. Authorities suspected Thompson, but they learned later that someone else was responsible for the theft—another false alarm.

Nancy DeButts Ambler told her grandson Jeff Urbanski that so many men were searching for Thompson she fed them from the cellar of Mt. Welby, the family's three-story, 1854 home.[30] "They'd just come in the door, and she'd send them through with sliced biscuits, put a piece of ham on it, butter, and send them out the door with spring water," Urbanski said. The house was part of the 505-acre DeButts farm at the foot of Rattlesnake Mountain. Most of the farm has since passed from the DeButts family, but Urbanski, in his sixties, and his sister still own a piece of it. The old house has since been converted into an upscale bed-and-breakfast. Urbanski, a kennel owner and former marine, lives across the road.[31]

Many white people in the area locked their doors in fear of Thompson. The Herrell family has lived on the family farm at the foot of Rattlesnake Mountain since the 1700s. Mary and Barbara Herrell, two sisters now in their sixties, are the current residents. Barbara Herrell cleans houses for local residents. She said her great-uncle, Philip Thorpe, tried to go to the store in Markham when the hunt for Thompson was underway but couldn't because the roads were blocked by the posses. He reported that Thompson was going from house to house, raping white women. Barbara said her grandmother Angie was afraid to go to the barn or the henhouse by herself. "She made

Mt. Welby, home of the DeButts family. *Courtesy of Michel Heitstuman.*

The DeButts family home has been renovated and renamed as a bed-and-breakfast; it is now called Mount Welby. *Courtesy of Michel Heitstuman.*

Mount Paran Baptist Church. *Author's collection.*

her son go with her every time, and he had to carry a gun," she said. If they needed firewood, for example, they would go together, with the son telling his mother, 'Here, you hold the gun, and I can cut the wood faster.'"[32]

Black people lived in terror, too, although theirs was the fear of revenge. Sam Poles, a black resident of the county, said his grandparents were told that it would be safer for them if they remained in their house while the hunt for Thompson was underway.[33] Even so, some armed men stormed the houses of black residents, searching for the fugitive. One posse found a backwoods still, got drunk and shot up Mount Paran Baptist, the black church on Africa Mountain. "Everybody was mad at black people," said Melvin Poe. One group of men went to Thompson's house and found Ruth, his wife, and Grover, her son. There they staged a mock lynching, making Ruth stand on a rock fence, putting a rope around her neck and threatening her and Grover if she didn't tell them where her husband was. But she didn't know, and they left. Later, three of the Thompsons—Ruth, Grover and Raymond, Shedrick's brother—were arrested and placed in jail in Warrenton "for investigation," according to one news report.[34] Authorities may have hoped to pressure the three into telling what they knew about Thompson's whereabouts, or they might have decided that incarceration was the best way to protect them from their angry neighbors. Reverend Allen Baltimore, now in his nineties, was once a member at Mount Paran and is retired now, living in nearby Front Royal, Virginia. He recalled that when armed men came to his house, Tom Baltimore, his father, tried to defuse

their anger by identifying individual members of the posse. "Hello, Cousin Frank," he said. "Hello, Cousin Stanley." It was also a subtle reminder that they were probably related, since white men had fathered children by local black women.[35]

In a front-page letter to the editor of the *Front Royal Record* newspaper, Lelia Montague Barnett complained about the "stupid and cruel treatment" of innocent black people at the hands of these posses. "Some of the methods adopted seem to me to be so bungling and so brutal that it is bound to arouse resentment in all fair-minded people," she wrote. Barnett said that she watched an armed posse take the word of a child to raid a black community near her home. "Without warrant they entered the home of one of the leading colored families here, searched through it, even opening bureau drawers, using insulting language and threats," she wrote. "The dreadful deed which has taken place in our midst leaves us all in fear and keen resentment—colored as well as white—but in order that justice should be done, justice should be shown. A respectable colored family has as much right to fair treatment as one of the white race."[36] Guy Jackson, in recalling the tension, concluded that the problem was that too many "common" people took part in the hunt. "They turned them out with a gun, and they just did everything, drank whiskey and caroused and carried on," he said.[37]

A note that appeared in the social column of the *Fauquier Democrat* one week after the attack gave some measure of the intensity of the search. The twice-weekly paper, based in Warrenton, noted that Sheriff Woolf "plainly showed the effects of nine days and nights of intensive work in the Markham neighborhood. Perhaps he has been here during this time, but certainly has been little seen." Woolf told the paper that he was disappointed but not discouraged that the fugitive was still at large, and he vowed that "the search for the criminal Thomson has just begun."[38]

Chapter 3

HENRY AND MAMIE BAXLEY

A t Fauquier County Hospital, Henry Baxley was treated but not admitted, so he stayed with friends when not at his wife's side. He had several injuries, and one person who saw him said later that his face was swollen and bruised. From Mamie's hospital room, Henry wrote letters with "1½ hands, on a magazine in my lap."

His correspondents included his friend Harry F. Byrd. Byrd was one of Virginia's most powerful politicians, serving as governor from 1926 to 1930 and as U.S. senator from 1933 to 1965. Byrd also was a neighbor and fellow apple grower. He lived in Berryville, about thirty miles from the Baxleys, and liked to visit them in Markham and hunt quail on their farm. Both men were Democrats, and Baxley, as chairman of the local Democratic Party, supported Byrd's many political campaigns.

"I have just seen in the paper of the assault made upon you and Mrs. Baxley," Byrd wrote on July 20, three days after the attack. "I am very much distressed, and I hope your injuries are not serious. Could you have someone write me how you are, as I am much concerned."[39]

Henry replied to Byrd the day he received the letter, reporting on his wife's condition: "She both looks and feels better this morning. While the doctor has not committed himself as to how much longer he thinks she will have to be in the hospital, I am hopeful that another week will find her well enough to leave." In a later letter to Byrd, Baxley offered more details: "It is a miracle that Mrs. Baxley is in the condition she is. For several days she was very uncomfortable but she is easier now. There are two very bad cuts on

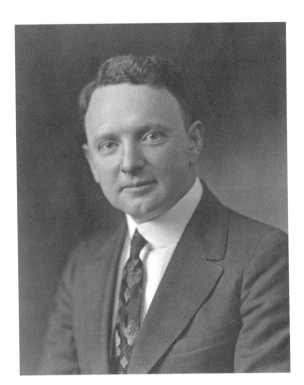

Right: Governor Harry F. Byrd. *Courtesy of Library of Virginia.*

Below: One of the letters Henry Baxley sent to former governor Harry F. Byrd while Mamie Baxley was at Fauquier Hospital. *Courtesy of Tom Davenport.*

her head and one ear is bothering her, but the doctors feel that her injuries are not serious. My injuries were minor compared to hers. My left forearm (one bone) was fractured, my left hand bruised a little and several cuts on the head, all of which are coming along satisfactorily."

Mamie was eventually able to rest and to receive visitors. Even so, by July 26, more than a week after the attack, she was still having problems. "She is

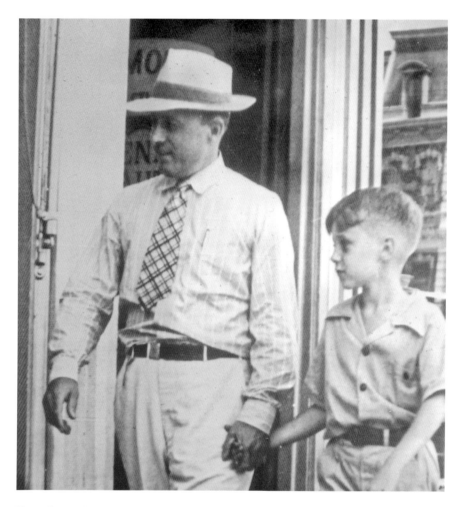

Henry Baxley Sr. and his son, Henry Baxley Jr. *Courtesy of Tom Davenport.*

very comfortable except for her head," Baxley told Byrd. "At times it aches some, and she still has the dizziness when she moves it." Dr. Barton Hirst, a gynecologist and Henry's uncle, came from Philadelphia to check on her. He was optimistic about her recovery, and she left the hospital after about ten days, first to stay with family friends, Mr. and Mrs. Thomas Frost, and then to return to Hume and the Cove.[40]

Henry also told Byrd that he was grateful Henry Jr. was untouched during the attack. "It is only by the grace of God that our lives were spared," he wrote. Yet he was worried about his wife. "For a while, I was uneasy about her," he wrote in another, "but I am encouraged enough to believe that her

physical injuries will soon be entirely healed. However I cannot help but view the future with considerable concern. If there was only some way to prevent the return of the horrible mental pictures. I realize time in some ways softens things, and my chief comfort is that surely Providence will deal kindly with her in this too."[41]

Henry was right to be worried about his wife. Friends said that after the attack, Mamie was not the same outgoing person she had been, as if a veil had descended to separate her from the rest of the world. Barbara Herrell said that she got to know Mamie many years later, when Mamie was one of the "Golden Girls," a group of elderly women that met regularly for tea.

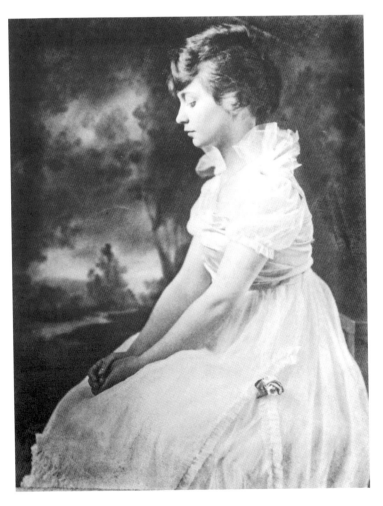

Mamie Baxley. *Courtesy of Tom Davenport.*

Herrell, who lives on her family's farm near Rattlesnake Mountain, said that Mamie probably would have benefited from a support group or professional counseling, but those therapies were not in use at the time. "You could look into her eyes, and you could see something there," Herrell said. "You didn't go there, and she didn't want to go there."[42]

Henry Jr., her son, said that his mother was not reclusive, but neither was she adventurous. She was "a loving, wonderful mother, but not a lot of fun," he said.[43] When she lived in a nursing home in Fairfax County, Mamie would not let any of the male attendants touch her. Henry Jr., eighty-six, is retired now after a career as a civil engineer and surveyor. He and his wife, Ursula, have three

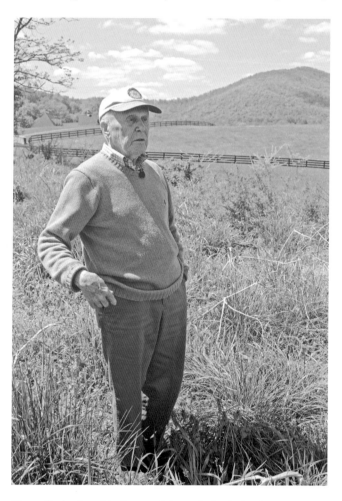

Henry Baxley Jr., with Oventop Mountain in the background. *Author's collection.*

children and returned to Fauquier in 1981 with the purchase of Meadow Grove, a property north of Warrenton. "I enjoy the fact that when the leaves are off the trees, I can still see the same undulating top of the Rattlesnake that was prominent from where I grew up," he wrote in his family history.[44] Baxley said he was too young at the time to remember Thompson's attack, and it was something that was rarely talked about in his family. His father told him about it when he was a teenager, but his mother never mentioned it. "As I was growing up, I had no idea that she or the family had undergone such a traumatic experience," he said.

Finally, near death and seated in a wheelchair in the medical wing of a nursing home, Mamie said to her son, "Hen, there's something I want to tell you. When I was young and you were a baby, I was raped by this colored man, who took me and dragged me off." In recalling the incident, Henry Jr. said, "I feigned shock. I didn't want to let her know that I had heard about this."

"Is this something that just came to your mind?" he asked her.

"No," she replied. "I've thought about this every day of my life."[45]

In attacking the Baxleys, Thompson struck at the heart of the Fauquier establishment. Henry and Mamie were born to privilege, the children of two of the county's most prominent families. Henry was thirty-three at the time, and Mamie was thirty-five. "The indignation is intense," noted the *Fauquier Democrat* in a front-page story about the attack.[46]

Henry Little Baxley was born on September 30, 1898, at the family farm in Markham. His father was J. Leroy Baxley, or Cousin Roy to his neighbors. His mother was Emily Hirst, better known as Tootie. The Hirst family was from Philadelphia. As was common in those days, they escaped the summer heat in the city by taking the train to the country. The Hirsts enjoyed Virginia, where they rented rooms from Fauquier County families. During one of these visits, Emily met Leroy, and the two eventually married. Emily gave birth to one child, Henry, but she died in 1900 at age twenty-seven. Henry was two at the time, and he told people that he grew up with no memory of his mother. The marriage had been a happy one. Leroy would tell friends that "living with her was like living in the Garden of Eden." Later, when he built the house where the attack occurred, he used money that he inherited from his wife and called the property Edenhurst.

Leroy was outgoing and enjoyed visiting neighbors. And as a single father, he often needed someone to help look after his young son. He was the son of a farmer and continued the family business, but he also planted apple trees and created a successful commercial orchard. He was one of the

J. Leroy Baxley. *Courtesy of Tom Davenport.*

founders of a bank in Warrenton and was on the board of a second bank in Marshall. In 1920, he purchased Morven, one of Markham's finest old homes, from the descendants of John Marshall, former chief justice of the United States.

Henry grew up working with his father on the family farm, eventually assuming more of the responsibilities. Henry Sr. was "short, stocky and strong," recalled Henry Jr. in his family history.[47] Henry Sr. could handle barrels of apples that weighed more than he did, and early on, he learned to drive the farm truck. One of his jobs was to take truckloads of apples and livestock to the markets in Baltimore, Maryland.

When he filled out his draft registration papers at age nineteen, Henry described himself as a man of medium height and build, with blue eyes and light-colored hair. In one family photo, he's wearing a dress shirt with sleeves rolled up, revealing powerful forearms. Another photo shows him

Henry Baxley. *Courtesy of Tom Davenport.*

smiling, arms crossed, with a felt fedora, white shirt, bow tie and a pocket full of pens. He attended school in private homes, and then later, when the brick, two-story public school was built in Hume, he walked or rode a mule to attend classes. He played second base and managed the baseball team in Hume. At the Hume school, he and Mamie Yates, who would become his wife, were among the three graduates in the class of 1915.

Henry attended Randolph-Macon Academy in Front Royal but did not go to college. He was twenty when drafted for World War I. His time in the

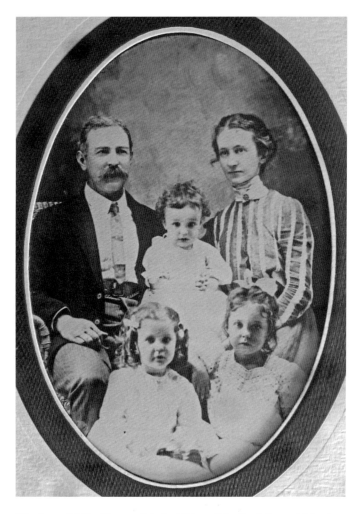

Charles and Juliet Yates and their children: Charlie, Juliet and Mamie. *Courtesy of Henry Baxley Jr.*

military was brief, and his duty station was close to home. He was a private in the Quartermaster Corps, stationed at Fort Meigs in northwest Washington. The armistice came one month after he was drafted, and he was discharged in January 1919, three months after induction. A family joke was that the German kaiser surrendered when he learned that Henry had joined the army. He returned to Fauquier after military service to marry and operate the family farm and orchard.

The woman he married, Mamie Maxfield Yates, was born on June 19, 1897. She was the oldest of three children and was about three years old

when her family moved across the Rappahannock River to Fauquier from the village of Flint Hill in Rappahannock County. Her grandfather James E. Yates was a wealthy businessman and landowner. He was one of the largest cattle dealers in Virginia and had been a purchasing agent for the Confederate government during the Civil War. Before his death, James Yates gave each of his three children large tracts of land. Mamie's father, Charles Yates, inherited 2,100 acres in Fauquier, near Hume, land that had been in the Yates family for years.

In about 1900, Charles Yates built a home on this land. For his homesite, he chose a cornfield on a hilltop, a splendid setting with an unobstructed view on three sides of the Oventop, Pigeon Perch, Buck and Rattlesnake Mountains. Because of the surrounding mountains, he called his property the Cove. Yates built a three-story, Queen Anne/Victorian house, with five bedrooms and an eclectic collection of towers, porches, gables and bays. It was unlike any other house in the county and quickly became a family treasure.

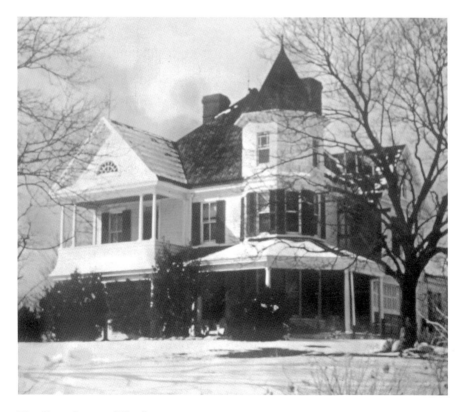

The Cove. *Courtesy of Tom Davenport.*

Farm near Sperryville in Rappahannock County, adjacent to Fauquier, 1935. *Courtesy of Library of Congress.*

It was the scene of many after-church dinners on Sundays and became a home for boarding schoolteachers and relatives who stayed for extended periods. At various times, all three of the Yates children, accompanied by their spouses and children, returned to live there. Henry Baxley Jr. estimated that his mother may have spent half her life there. He described the Cove as "a dear, distinctive structure" and her "home always." It became a true cove, or sanctuary, after Thompson attacked her.

The Cove also was a self-sufficient farm, where four-horse teams, rather than tractors, did the heavy work of plowing, hauling and harvesting. Farms in the area raised wheat, barley, corn and vegetables. Livestock included cows, hogs, chicken and turkeys. Most of the wood used in the construction of the house came from the farm.[48]

Charles Yates lived in his house for only fifteen years. He died in 1915 of Bright's disease, leaving Juliet, his forty-five-year-old wife, with a large estate and three teenage children. But Juliet—or "Mun," as her grandchildren called her—had been born to farm life, and with the help of a good farm manager, she successfully handled all the operations, including writing checks and buying and selling cattle. To Henry Jr., his grandmother was also the emotional center of the family, the sun around which the others orbited.

"She wouldn't have struck you as being belligerent or forceful, but she knew what she wanted and everybody respected her," he said.

When Mun remarried three years after Charles Yates's death, she chose E. Marshall Newton, who lived nearby and was related to her by marriage. Newton was an insurance agent, one of the founders and directors of a local bank and the treasurer of Leeds Episcopal Church. He was also the widower of Charles Yates's half-sister, Elizabeth, who had died the same year that Charles did. Henry Jr. said he was not sure if the marriage between Mun and Uncle Marshall, as he called him, was a union of romance, practicality or both. He does remember that his mother, Mamie, was not happy with the marriage, saying that Mun did not wait long enough to remarry. Mun refused to leave the Cove after the marriage and insisted that her new husband and his children move in with her. So Mun's brood grew to six: her three children and their three half-cousins.

Like Henry, Mamie attended school in private homes in the area and then the new, brick public school in Hume. She was "a smart, petite, attractive, popular brunette," recalled her son.[49] Her classmates elected her president of the student body and captain of the basketball team. Everyone enjoyed the parties she hosted with her sister at the Cove. At one Halloween party, "everyone who didn't come in costume was given a sheet to wear," recounted Henry Jr. The room over the front door was decorated and darkened for the occasion, and guests were welcomed with a handshake from a glove full of ice.[50] Mamie graduated from high school with Henry and then returned as a teacher's aide. When Juliet, her younger sister, graduated, the two of them went to Mary Baldwin Seminary in Staunton for two years.

Henry was but one of Mamie's suitors, and he courted her with a series of love letters, which she saved. It was a correspondence that would not have existed if the county roads had been better or if there had been widespread telephone service. "Father would write and mail the letter in Markham. She would get it in Hume, and he would get a reply the same day," said Henry Jr. A formal photo of Mamie, taken in her white satin wedding dress, shows her in profile, seated with hands folded in her lap. Her brown hair is swept back in a boblike style popular in the mid-1920s. Her wedding day came two weeks before her birthday, in June 1923. She was twenty-five; her husband was twenty-four.

The wedding was front-page news in the *Fauquier Democrat*, with the story headlined, "Miss Maxfield Yates Weds Henry Baxley."[51] The newspaper described the three candlelit arches in front of the chancel rail at Leeds Episcopal Church in Markham. It said that Mamie looked lovely in her

Mamie Baxley. *Courtesy of Tom Davenport.*

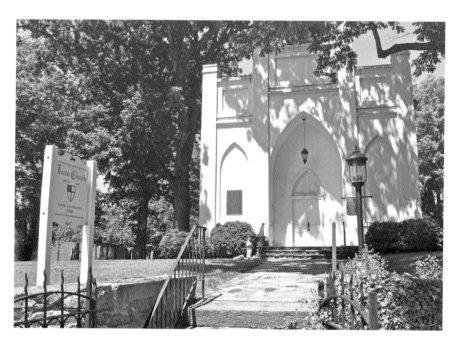

Leeds Episcopal Church. *Author's collection.*

white satin dress with tulle veil and orange blossoms and her shower bouquet of white roses. Mamie entered the church on the arm of her stepfather, E. Marshall Newton. Her sister, Juliet, was maid of honor. Henry's cousin Dr. Haughton W. Baxley from Boston, Massachusetts, served as best man. A large reception was held at the Cove, and the couple traveled by car to Washington and then Atlantic City for the honeymoon.

When they returned to Fauquier, the newlyweds moved into Edenhurst, and Henry continued to help his father on the farm and in his apple orchards. Leroy Baxley had built Edenhurst in about 1900, intending to give it to his son when Henry turned twenty-one. The two-story Colonial, with yellow stucco exterior and metal gable roof, sits on a rise off Leeds Manor Road, in the shadow of Buck Mountain between Markham and Hume. Today, it is surrounded by barns, outbuildings, a pond and two hundred acres of fenced pastures. Next door is a commercial winery. Fauquier County values the house and farm at almost $3 million.

In his family history, Henry Jr. described his parents' life there as "happy times, punctuated by parties with paper Japanese lanterns, decorated porches and lawns, and visits to and from friends and relatives far and near." That ended suddenly in the summer of 1932, when Thompson slipped into the house and attacked them. At Mun's insistence, Mamie returned to the Cove to recover. She, Henry and their infant son moved into a bedroom over the dining room. What started as a temporary stay became permanent, and the family remained at the Cove for more than fifteen years. Finally, after World War II, the Baxleys bought a nearby farm, Ploughshares, and moved there.

Edenhurst. *Author's collection.*

"Her life at Ploughshares was pleasant and quite routine," Henry Jr. wrote of his mother. "She was a good cook, but the kitchen routine was frustrating due to Dad's eating peculiarities: no eggs or dairy products, turkey was OK but not chicken. Dinners tended to include a lot of fish sticks."[52]

Henry Sr. returned often to help farm Edenhurst, but he eventually arranged for the Pearson family to live in the house and take care of the property. Henry Jr. said it must have been difficult for his father not to have a house of his own for all those years. But in a tribute to the Cove, and especially to his grandmother Mun, he added, "I don't remember him ever showing it or not seeming to feel at home at the Cove."

SHEDRICK THOMPSON

E arly in the search for Thompson, Sheriff Woolf called authorities in Martinsburg, West Virginia, to ask for their help. Thompson had a reputation as a person who moved around a lot, and he had been staying with friends in Martinsburg, about 60 miles from Fauquier, just before the attack. When Woolf called there, he asked for Thompson's clothes to help the bloodhounds pick up his scent. William Schill, a member of the police department in Martinsburg, retrieved the clothes from the house where Thompson stayed and sent a bill for five dollars for delivering them by auto, 110 miles round-trip to Markham. "If you have a circular or picture of Thompson, please let me have one," Schill wrote. "We are on the job in case he comes here."[53] Later, Woolf drove to Martinsburg to visit Thompson's old home, but its occupants denied that Thompson had been there. Two weeks before the discovery of Thompson's body, Martinsburg authorities heard that a man believed to be Thompson was living in a hut in the eastern part of the city, but that tip proved false.

Woolf did prepare a wanted poster, but it contained only a description of Thompson—no picture. The poster described Thompson as tall, dark and well built. He had a faint birthmark behind his right ear extending down his neck and a dent on the left side of his chin. The poster also hinted at violence in Thompson's past when it described an enlarged middle knuckle on the index finger of his right hand, the remnant of a gunshot wound.[54]

The Baxleys told neighbors that broken pieces from the wood club Thompson used to batter Henry were found throughout the house. They

$250.00 REWARD

A reward of $250.00 will be paid for the arrest, dead or alive, of Chad Thompson, colored. Color brown; height 6 feet; weight 190 pounds. Wanted by authorities of Fauquier County for assault.

C. W. CARTER,
Commonwealths Attorney.

W. S. WOOLF,
Sheriff.

The first of three wanted posters for Shedrick Thompson. *Author's collection.*

Cherry Hill School for black children on Little Africa Mountain. *Author's collection.*

also said Thompson carried a handgun that night but did not use it. Later, they found the gun on the stairs. Other accounts said that Thompson was a former convict and was wearing a blue work shirt and blue overalls when he attacked the Baxleys. One story said that he wielded a huge whip and struck Mamie with it when he marched her across the pasture. He is also said to have tied her with the same piece of rope that was later found around his neck and that he promised Mamie that he would spare her if she agreed not to contact the police until 10:00 a.m. so he could escape. But the wanted poster made no mention of any of this. It appeared in the *Fauquier Democrat* two days after the attack and offered a reward of $250, the equivalent of $4,300 today, for "the arrest, dead or alive, of Chad Thompson, colored."[55] The poster was signed by Woolf and C.W. Carter, the commonwealth's attorney. The *Democrat* published the poster three times, including once on the front page. In the second notice, the fugitive's name was changed to "Shad Thompson." Finally, for the third publication, Thompson was correctly identified as Shedrick Thompson. Also, authorities dropped the "dead or alive" offer and said that they would pay the reward only for Thompson's arrest.[56]

The man they sought was a native of Fauquier and third-generation Virginian. He was the third of nine children of Marrington and Fannie Thompson, born on January 4, 1893. His sister Katie was firstborn and five years older. His brother Raymond was two years older. Shedrick attended

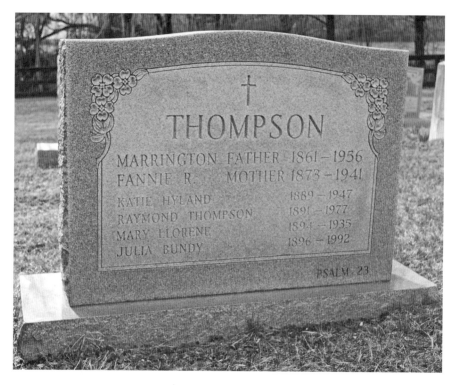

The Thompson family marker at Mount Morris Community Cemetery near Hume. *Author's collection.*

Cherry Hill, the school for black children, where he learned to read and write. But education was limited. Black students attended classes only in winter; the rest of the year, they were expected to work in the fields. In addition, Cherry Hill went only through the eighth grade. At the time, Fauquier did not have a public high school for blacks.[57]

Marrington Thompson was born in Virginia in 1862, the son of Virginia-born parents. He never attended school and could neither read nor write. Fannie Thompson was also born in Virginia, in 1868, the daughter of Virginia-born parents. She completed the fifth grade and could read and write. It is not known if Marrington's or Fannie's parents were slaves. The Thompsons married in 1890. She died in 1941 at the age of seventy-three. He lived until 1956 and died at the age of ninety-four.[58]

Like his father and older brother, Shedrick was a farm laborer. He worked for the Baxleys, first Leroy Baxley and then his son, Henry, and for other families in the area. As a farm worker, he cleared land, planted and harvested crops, cut firewood, cared for animals, built fences, picked rock and tended

fruit trees. His wages included a house to live in, and he may have received "allowances," including hogs, meal, flour and chickens.[59] He also earned a small amount of cash, as little as a nickel a day. "Everybody who worked on farms got the same arrangement—a little money and some payment in farm produce," recalled Alphonso Washington.[60] But this was the Depression, and cash was scarce. As in other rural areas in Virginia, Fauquier residents were familiar with one of the ironies of the Depression. They enjoyed fresh meat, homegrown fruit and garden vegetables, yet many couldn't afford to buy something as simple as toothpaste.

In June 1917, when the first of four draft registrations was held, Thompson signed up. More than 4,100 young men from Fauquier registered for the draft, although only 86, including Thompson and his older brother, Raymond, were drafted.[61] The United States had just entered the war in Europe, and President Woodrow Wilson ordered a nationwide draft of all men, black and white, ages twenty-one to thirty-one. Thompson did as required, despite the critics who questioned why black men would fight for a country that denied them basic rights. "Colored soldiers filled their quotas and accepted the draft cheerfully," wrote Meta Gaskins in her 1925 history, *Fauquier County in War Time.* "Their loyalty was the more commendable because there was reason to believe that German propagandists had been at work among them as in other places."[62]

Thompson's draft call came in June 1918. He was inducted one month later in Helena, Arkansas, and trained at Camp Pike, about 120 miles west, near Little Rock. He earned fifteen dollars per month as a private with Company D of the 544th Engineer (Colored Service) Battalion and went to St. Nazaire, France, in October 1918, just weeks before the armistice was signed. His unit served with the First Army during the Meuse-Argonne campaign. He spent ten months overseas, working as a laborer, building roads and then loading ships during the demobilization. One photo of his unit shows the soldiers tearing down stone walls in Nantillois, France, in preparation for a road. He returned to the United States to be honorably discharged from Camp Pike in August 1919.[63]

Lieutenant Ludwig Schmidt, who commanded the black troops of the 544th Engineer, wrote after the war that the soldiers got to the front line late but experienced heavy fighting at Auberville, France. "It must be kept in mind that most of those in the battalion had, before the war, never been farther from their home than the nearest trading town," he wrote. "Military drill was a great obstacle. They had followed a one-mule plow too long."[64]

Schmidt could have been writing about Thompson, who was twenty-five when he went away to war. In little more than a year, he traveled halfway across the country for training and then across the Atlantic to fight in Europe. He served in a segregated army with more than 300,000 other black soldiers, some of whom were angry about their inferior treatment. Like many army camps, Camp Pike offered black soldiers inadequate training and second-rate food, clothing and equipment compared to

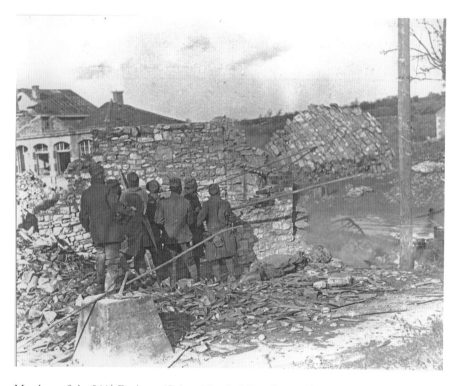

Members of the 544th Engineer (Colored Service) Battalion work on a road in Nantillois, France. *Courtesy of U.S. National Archives.*

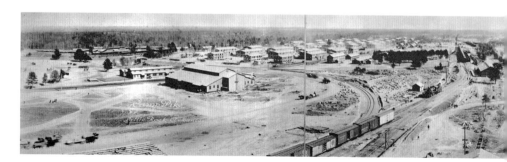

white soldiers. When Thompson arrived at Camp Pike, the army base had just experienced what one newspaper described as a "mild riot" between white and black soldiers in the mess hall. A white soldier was hit in the head with a brick and required three stitches; 26 black soldiers from the 512th Engineer (Colored Service) Battalion, Thompson's unit, were in the stockade, awaiting trial by general court-martial. The incident began when one black soldier slapped another, took his place in the breakfast line and then demanded food from a white mess sergeant. The mess sergeant ordered the soldier to return to his place in line, but the soldier refused; brandishing a razor, he climbed over the serving counter to get to the sergeant. Others joined in the fray, and soon "the air was full of flying mess kits, salt cellars and other tableware," according to one newspaper account. The newspaper described the soldiers as "general trouble-makers, although they have not been in the service long enough to have a court-martial record."[65]

When Thompson returned from overseas in the summer of 1919, again to Camp Pike and rural Arkansas, he found a nation in turmoil. The summer and fall of that year saw race riots in more than three dozen cities, including Washington, Chicago, Knoxville and Charleston, South Carolina. One of the worst incidents occurred in Phillips County, Arkansas, near Camp Pike. In October of that year, black sharecroppers met at a church to discuss hiring an attorney to help get what they believed was a fair share of the cotton crop they had planted. Two whites showed up outside the meeting, and shots were fired. When the shooting stopped, at least twenty-five blacks and five whites were dead. More than five hundred white soldiers from Camp Pike helped quell the disturbance, although there were reports that the soldiers also fired on local black civilians.[66]

Thompson was in Phillips County at the time of the riot, although there is no evidence that he was involved in it. His military records indicate that he remained in Arkansas for several months after his August discharge. On two

Camp Pike, Little Rock, Arkansas, 1918. *Courtesy of Library of Congress.*

documents, dated February 1920, he listed his address as St. Francis Street, near the Mississippi River, in Helena, the county seat.[67]

Given the things Thompson saw while he was away from home, the people he met and the views he heard expressed, it is interesting to consider how they might have changed him. Did army life in France sharpen his views on farm life in Fauquier? Did the racial tensions in rural Arkansas mirror those of rural Virginia? If Thompson thought that his military service in France would help him win equality back home, he was mistaken. His economic, political and social options were still limited. Little had changed.

Again, it's not clear how, or if, Thompson's experience in the army affected him. But historians have described a new defiance among many returning black soldiers, how they became early civil rights workers, with attitudes born of the discrimination they experienced in the army and the way they were treated at home. As one wrote, "The post–World War I era witnessed the creation and empowerment of the 'New Negro,' marked by confidence, assertiveness, and belligerence."[68] And in 1919, W.E.B. Du Bois, editor of *The Crisis*, the NAACP's monthly magazine, said of the returning black soldiers, "By the God of Heaven, we are cowards and jackasses if now that the war is over, we do not marshal every ounce of our brain and brawn to fight a sterner, longer, more unbending battle against the forces of hell in our own land."[69]

It is also interesting to note that Thompson's assault on the Baxleys occurred while the Bonus Army was camped in Washington. Thousands of World War I veterans, white and black, descended on Washington from across the country in June and July 1932. Congress had appropriated a pay supplement for them in 1924, based on length of service, but the bonus payments were not due for twenty years. Thompson, for example, was to receive $452.00, including an extra $0.25 per day for his time overseas. He applied for the special supplement in 1931 and, like other veterans, was awaiting his money.[70] But many of the veterans, unemployed and impoverished by the Depression, did not want to wait. More than twelve thousand came to the city as part of a massive lobbying effort. Many camped in a makeshift city in the mud flats beside the Anacostia River. The House approved a bill that would advance the payments, but the Senate rejected it. Many veterans reacted to this defeat not by leaving Washington but by intensifying their protest. On July 16, one group camped on the Capitol lawn, while another group marched on the White House. Less than two weeks later, President Herbert Hoover ordered the army, led by General Douglas MacArthur, to clear the camps and evict the veterans. Two of the veterans were killed during the army action.

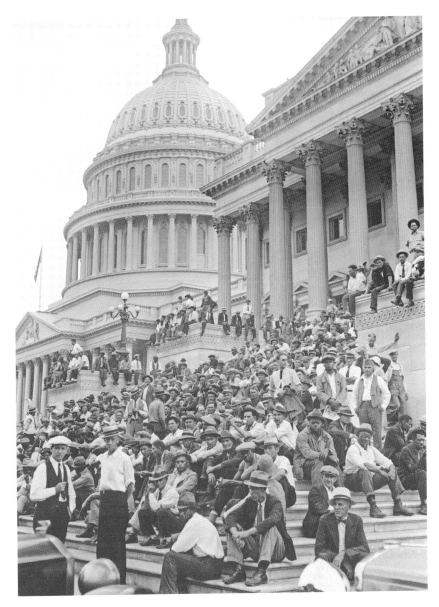

Members of the Bonus Army at the U.S. Capitol, 1932. *Courtesy of Library of Congress.*

On July 17, forty miles away in Fauquier, Thompson attacked the Baxleys. There is no evidence that he traveled to Washington to join the Bonus Army or even knew about the protest. Yet their cause was his cause, and it's tempting to consider whether official Washington's reaction to the protest

played a role in what Thompson did to the Baxleys. Was the attack payback for the indignities Thompson experienced during and after the war? Were the Baxleys surrogates for those who treated him unfairly?

This question of motive is still one of the most puzzling aspects of Thompson's attack. One theory that was popular afterward, especially among blacks, was that a defiant Thompson was fed up with the Baxleys and wanted the back wages they owed him.[71] This theory held that the family was losing money on its farm operations and had not paid Thompson for three years. In a drunken rage, he exacted his revenge.

Thompson's actions created a dilemma for black residents. They did not condone his violence against the Baxleys. Henry and Mamie were popular in the community, with Henry especially described by both blacks and whites as a kind and thoughtful man. Reverend Lindsay Green, seventy-four, the black pastor at Mount Morris Baptist Church in Hume and longtime resident of the county, remembered years later how Henry would give him a ride to Warrenton, twenty miles away, to the county's only black high school, when Green missed the school bus.[72]

Reverend Lindsay Green. *Author's collection.*

But blacks also understood the realities of life in rural Fauquier. They knew firsthand the limited opportunities and the perils of their second-class status. They, more than whites, could see the complications in Thompson's life, the frustrations like unpaid wages that might ignite a simmering rage.

Guy Jackson, a black friend of Thompson's, typified this dilemma. Jackson was thirty-three at the time of the attack, a few years younger than Thompson. He was a native of Fauquier and lived most of his life in the county. He raised a family on Africa Mountain and worked at a variety of jobs, including sharecropper, lumberman, truck driver and, during World War I,

factory worker at a munitions plant in Philadelphia. He picked apples and peaches at many of the local orchards and eventually earned ninety cents per week as foreman of the picking crews. Jackson and Thompson were friends and played cards frequently at Thompson's house, and the two rode horses together. After Thompson attacked the Baxleys, Jackson's brother, James, helped Mamie. Years later, when Guy Jackson was asked about the attack, he said he still struggled to understand why it happened. Jackson said that he liked the Baxleys and did not condone Thompson's attack on them. "There ain't nobody that'll take sides with a man that go out and do good people that way," he said.[73]

Still, blacks were more willing than whites to consider speculation that reflected badly on the Baxleys. Reverend Lindsay Green, for example, said that some blacks believed that the attack was in retaliation for Henry having an affair with Ruth Thompson, Shedrick's wife. Reverend William Gibbs, sixty-five, who is black, grew up in Fauquier and served as pastor at

Reverend William Gibbs. *Author's collection.*

Providence Baptist Church in the Orleans section of the county, said that when his parents and neighbors talked about the incident, they said the attack stemmed from an affair between Mamie and Thompson.[74]

The most frequently held theory, however, is the one mentioned by Guy Jackson in a 1973 interview. "He seemed to have the impression that the white people put his wife up to leaving him," Jackson said.[75] According to this theory, the incident started weeks earlier when Thompson attacked his wife. Ruth Thompson obtained an assault warrant against her husband, and Thompson fled to West Virginia. He had been missing from Fauquier for about six weeks before the attack on the Baxleys and had recently returned and was staying with his mother.[76]

Ruth and Shedrick Thompson had been married for eleven years when the attack occurred. Like her husband, Ruth was from a longtime Fauquier family. She was the daughter of Hayes and Kitti Hackley, and friends called her "Piney." She and Shedrick were living in Prince William County, Virginia,

Guy Jackson. *Courtesy of the Gaskins family.*

when they married. The marriage took place in Manassas, the county seat, in March 1921. He was twenty-eight; she was twenty-two. It was the first marriage for both, although Ruth had a six-year-old child, Grover, the son of Shedrick's older brother, Raymond.[77] The family eventually returned to Fauquier, and by 1930, they were living next door to the Baxleys.

The late Elsie McCarty, a friend of Mamie's and a lifelong county resident, said during a 1994 interview that Mamie Baxley had criticized Thompson for the way he treated his wife. "You mustn't treat [Ruth] so badly," Mamie told Shedrick. "She's a fine woman, and you're lucky to have her for a wife."[78]

The *Front Royal Record* and the *Winchester Evening Star* offered variations of this theory in their coverage in the days following the attack. Former governor Harry F. Byrd, owner of the *Winchester Evening Star*, was a friend of the Baxleys and corresponded with Henry Baxley while he stayed with his wife at Fauquier County Hospital. Byrd's paper said, "Mamie told authorities that Shedrick was believed to harbor a grudge against her and her husband, who once had given information that resulted in the negro's imprisonment."[79] The Front Royal paper noted that Thompson may have believed that Mrs. Baxley sided with his wife in his fights with Ruth. The paper also said that Thompson "may have wrongly believed that Mr. Baxley had informed the authorities of his recent return since there had been official efforts to locate him."[80]

Finally, there is the possibility that Thompson was just an angry man prone to violence. One newspaper reported that Thompson would "frequently go on sprees when he would beat up his wife."[81] Sylvia Gaskins recalled, "All those Thompsons were mean and wild. My dad used to say even the girls would fight you in a minute."[82] Gaskins is black and still lives in Fauquier outside Warrenton. Her father, Guy Jackson, was friends with Thompson. Years later, Annabelle Thompson, the wife of Grover Thompson, Shedrick's stepson, told neighbors that even the black community feared her father-in-law. "He was erratic. He had a temper. People stayed away from him," she said.[83] Reverend Allen Baltimore, a former resident of Africa Mountain, recounted how Thompson once confronted Ruth outside Mount Paran Baptist Church after a service. Baltimore said that Thompson fought with his wife and threw her down in the parking lot. Thompson always carried two pistols and pointed one of them at her and pulled the trigger three times. But the gun did not fire. Someone got the pistol away from Thompson and pointed it to the sky. This time the gun went off.[84] Given this reputation, perhaps Thompson didn't need much of an excuse to attack the Baxleys. Perhaps he was a disturbed man, fueled by alcohol and the unbearable summer heat, and capable of almost anything.

Chapter 5

THE DISCOVERY OF THOMPSON'S BODY

A lthough intense at first, the search for Thompson inevitably slowed. The searchers had to return to their farm chores, and so they concluded, as one local paper put it, that Thompson "made his escape before the alarm was given."[85] Finally, two months after the assault, and with Thompson still at large, Henry Baxley turned to his friend former governor Harry Byrd for help.

At Baxley's request, Byrd wrote to Governor John Garland Pollard, a fellow Democrat, to see if the state would intervene. "My friend Henry Baxley of Markham accompanied by the Sheriff of Fauquier County are very anxious to see you Friday or Saturday," Byrd wrote on September 15. "If convenient, I would greatly appreciate you wiring Baxley direct [as to] the day and hour."[86]

It was an unusual request for help, the kind that Byrd never got when he was governor. Six years earlier, after the lynching of a farm worker in Wythe County, Virginia, local officials did not ask for the state's help and then refused it when Byrd offered. Later, Byrd lobbied for passage of a state anti-lynching law that said the state could intervene without invitation to investigate and prosecute a suspected lynching.

Pollard sent Baxley a telegram the next day, suggesting that they meet in his office in Richmond on Saturday, September 17. However, Baxley canceled the meeting at the last minute when a farmhand discovered Thompson's body on Rattlesnake Mountain.

As Baxley told the governor in a September 16 telegram: "Criminal's remains have been found." In a letter to Pollard, dated the same day,

Baxley wrote, "I am happy to tell you that the body of the criminal was found late yesterday evening hanging from a tree, having taken his own life, thereby putting an end to the man hunt."[87] Baxley also wrote to Governor Byrd to tell him the news: "Not long after I returned from Winchester yesterday the message came that the body of the negro had been found. It was hanging from an apple tree at the edge of Rattlesnake Mountain, within a 4 or 5 mile radius of where the crime occurred and evidently the work of his own hand. Although he had been dead for a considerable time it was possible to identify him without question." Baxley added, "With the finding of the body I trust that the last page of his

An apple tree at the foot of Rattlesnake Mountain. *Author's collection.*

horrible crime is completed, and I earnestly pray that no one will ever have to experience such an ordeal as this has been."[88]

Thompson had been missing for eight weeks, yet his body turned up as soon as Byrd, Baxley and Sheriff Woolf asked the state to intervene. The timing might have been a coincidence, but it's also possible that someone in Fauquier knew that Thompson had been lynched and that his body, still hanging in the mountains, bore evidence of that crime. So with news of the pending meeting in Richmond, the body surfaced. That meant that state officials could stay home. They were not needed in Fauquier.

The end came at dusk on Thursday, September 15. The poplars and sycamores were still in full leaf on Rattlesnake Mountain, but dabs of red and yellow signaled the approach of autumn. Noah Kenney, a white tenant farmer at the O.W. Borden farm, was following a fence line to see why his cattle were getting out. Kenney said later that he stopped to peer into a thicket to see if the fence rails were still in place, when he heard a squirrel above his head cracking nuts. When he looked up, he saw the body of a black man hanging from an apple tree. The body had obviously been there a while: the eyeballs were gone, and it was badly decomposed. Yet Kenney recognized the man as Thompson.[89]

The site was near the Warren County line, on the west side of the mountain, about two hundred yards from Kenney's farmhouse and about four miles over the mountain from the Baxley house. Today, the land is owned by Marriott International Inc., the $13 billion hotel chain. Marriott owns 4,100 acres in Fauquier, including a dude ranch. The hanging site was located beside what is today the ranch's riding stables. Apparently, Thompson's body had gone unnoticed because it was hidden by the trees and dense undergrowth. Some said that it could have stayed there for years, so impenetrable was the thicket that surrounded it. Chaz Greene, a Marriott employee and the current resident of the house Kenney lived in, said the woods behind his house are still so thick with undergrowth that once when he shot a deer there, it took him several hours to push through the tangle and drag the carcass back home.[90]

Kenney's discovery ended the largest manhunt in the county's history. Hundreds of people had searched for nearly two months. Yet now it was clear that Thompson had not fled far. He escaped into the mountains where he grew up—and died there.

Kenney immediately called the closest sheriff's office, in Warren County. Police there called Warrenton to alert Sheriff Woolf. Woolf, along with deputies from Fauquier and Warren and town police from Warrenton,

arrived at the scene at about 8:00 p.m., three hours after Kenney's discovery. By then, word had spread, and people had streamed to the site. Newspaper accounts estimated the crowd at 150 people. Some of the curious came from a Pentecostal tent revival that had been underway that week in nearby Hume. "When the news broke that they had found Shed Thompson, everybody left [the revival] and went to the mountain," said Melvin Poe.

W.W. Pearson, Poe's grandfather and Woolf's only deputy sheriff, arrived first from Hume to find a crowd of people surrounding Thompson's hanging body. He said later that he heard someone in the crowd say, "I wonder if he'll burn?" and another person reply, "Why don't you try him?" A third man lit a match. Pearson watched as the gruesome remains went up in flames. He took off his new hat and tried to put out the fire, but a man put a pistol in his ribs. "Get back," the man said. "Let it burn." So Pearson moved away, with nothing to show for his effort but a scorched hat. One rumor said that the crowd doused the body in kerosene so that it would burn easily, but Dr. George Davis, the coroner, said that kerosene had not been used. A decomposed body would burn rapidly because of the natural oils, he said.[91] Soon, all that was left of Thompson were his skull and shoes. The crowd scrambled for Thompson's teeth, removing them from the skull and distributing them as souvenirs. Two of the teeth were pounded like nails into a pear tree at Mt. Welby, the home of the DeButts brothers, according to family legend.[92] In describing the actions of the mob that night, one newspaper termed it a "post-mortem orgy."[93] Another noted, "That the feeling here against Thompson was intense was borne out by the actions of the mob in burning the body without awaiting the arrival of authorities."[94]

F.F. Hall, the town sergeant in Warrenton, gathered the rope and what was left of Thompson and brought them back to Warrenton. He placed the remains under the front steps of the Fauquier County Courthouse on Main Street, the symbolic heart of the community at the center of town, either for safekeeping or for display to interested onlookers. Arthur "Bunny" Nash, a white resident of Warrenton, remembered his father, James Mallory Nash, saying that he saw the remains of a black man who had been lynched, presumably Thompson, displayed there.[95] Dr. George Davis, a Warrenton physician and the county coroner, told reporters that he had Thompson's skull in his office for several days. It's not clear what happened to the remains after that. Critics pointed out later that the authorities who were at the scene should have protected the body so it could be examined for evidence of a possible crime. But that did not happen, and with the fire, all clues were

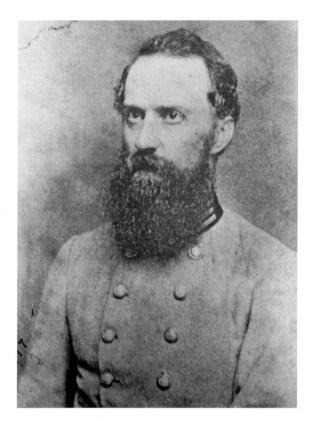

Left: Richard Earle DeButts (1823–1892) rode with Mosby's Rangers during the Civil War and was an ancestor of the DeButts brothers who hunted Thompson. *Courtesy of Tom Davenport.*

Below: Fauquier County Courthouse, Warrenton. After Thompson's lynching, his remains were placed beneath the courthouse steps. *Author's collection.*

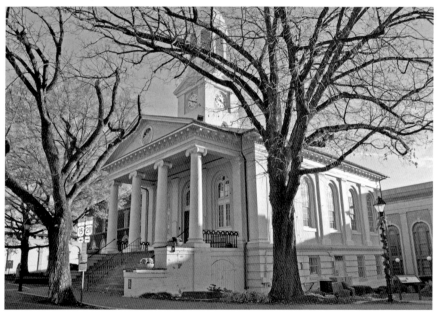

gone. Even so, Sheriff Woolf promised an investigation into how Thompson died and who burned his body.

Later that month, Kenney, the man who found the body, wrote to the clerk of the Fauquier Board of Supervisors to claim the $250 reward. "Please let me hear from you at once by return mail," he wrote.[96] The board of supervisors refused to pay Kenney. The reward was for the arrest of Thompson, board members said, not for the discovery of his body. Kenney disagreed and hired a Front Royal attorney, Walter G. Olmstead, to appeal his claim. Olmstead

Fauquier Mob Burns Body Of Negro Who Attacked Baxleys

Economic Situation Proves Tragic For Boys And Girls, Baker Declares

Washington, Sept. 15 (INS)—"can stay at home, of course, but The plight of boys and girls deprived of beginning their life work because of the economic crisis was stressed by Newton D. Baker, Wartime Secretary of War and Chairman of the National Citizen's Committee on the welfare and relief mobilization, assembled at the White House today. Baker spoke in response to the President's charge to the delegates of the responsibility rested in their hands for taking care of the unemployed during the winter.

"Industry and commerce both have their waiting lists of their old employees temporarily laid off, and as activity resumes former employees are recalled," Baker pointed out, "but the expectant boy sees no sign 'Boy Wanted', which is the usual announcement to youth that life has a place for him. Some of these young people

in increasing numbers they are burden and are taking to the open road so that it is now estimated that within the past few months three or four hundred thousand grown boys have left home, family and friends to live by the wayside to be gleaned from already harvested fields."

Insisting that acceptances of local responsibility is essential, Gifford said, "Any breakdown in this local responsibility will result in greater hardship to the unemployed who are in need. The number of those who will be permanently disabled as a result of this depression will depend upon how adequate and intelligent our relief is now, and how adequate and sympathetic our reconstruction work is as we come out of the depression."

Hope Fades County Fair For Missing Crowded On U. S. Plane Biggest Day

No Tidings Received From "American Nurse" On Trans-Atlantic Flight

Rome, Sept. 15, (U. S.)—Fear that the transatlantic monoplane

Races And Flower Awards Feature Events At Woodstock Yesterday Afternoon

Yesterday was the biggest day at the Shenandoah County Fair,

Decomposed Remains Of Shadrack Thompson Found Hanging To Tree On Rattlesnake Mountain

MYSTERY SHROUDES DEATH OF FUGITIVE

Corpse Is Discovered By Farmer Near Summit Of Blue Ridge Mountains

The body of Shadrack Thompson, negro who attacked Mr. and Mrs. Henry Baxley early on the morning of July 18 in their home near Hume in Fauquier County, was found hanging by the neck on the west side of Rattlesnake Mountain, on the old Hugh Miller farm, now owned by O. W. Borden, by Noah Kenny, a tenant on the Borden farm, about dark this evening.

Reports that the body had been found spread rapidly and a large crowd gathered. The gruesome remains were cut down and burned by the crowd. How the negro met his death is not known, since no examination of the body was made to determine the cause of death.

The body was in a bad state of decomposition, evidently having been dead five or six weeks. Kenny reported the find to Deputy Sheriff W. H. Dodson, of Warren County, who called the officials of Fauquier County on the telephone and informed them of the find. Special Officer W. W. Pearson, of Hume, accompanied Mr. Dodson to the scene of the discovery. Other officers from Warrenton were also on the scene.

The discovery of Thompson's body and its destruction were front-page news in the *Northern Virginia Daily* and other papers. *Author's collection.*

quoted from the first of the county's wanted posters, the one that offered the reward "for the arrest, dead or alive," of Thompson and asked the supervisors to reconsider. However, the board members were not moved and again refused to pay.[97]

Officer Hall was the first to offer what became the official version of what happened to Thompson. On the night the body was found, Hall told reporters that Thompson must have realized the seriousness of what he had done and known he was trapped. Rather than risk capture, he hanged himself, Hall said. Hall spoke within hours of the discovery of the body. Authorities had not interviewed witnesses or gathered any evidence, but they confidently answered in detail the months-long mystery of Thompson's disappearance.

Davis, the county coroner, described Thompson's suicide as "the simplest thing in the world." Davis explained that the apple tree had "one limb running straight out about the size of my leg in diameter and another limb a bit higher running in almost the same direction. Thompson climbed the tree and sat out on the limb while he tied the slip noose around his neck. Then he proceeded to tie the end of the rope to the limb leaving about eighteen inches slack to break his neck in the fall. After fixing the knots the negro allowed himself to slip off the limb. That's all there was to it."[98]

Thomas Frank, editor of the county newspaper, once teased Davis in print, saying that one could smell ether, an anesthetic, on the physician before you could see him. "Once you get that old ether odor, you will have no other," Frank wrote.[99] Still, Davis was one of the most important figures in the Thompson case. He was quoted at length by local reporters, explaining how Thompson died, and he issued the official cause of death. Davis opened and closed his investigation on the night the body was discovered, saying, "I hereby find that said Shedrick Thompson came to his death by hanging himself by the neck." He also listed the date of death as "on or about July 20, 1932."[100]

An inquisition taken at .near.Linden,...................................
in the county of Fauquier, on the....15th.........day of..September......
1932, before.......George.H,.Davis,..............coroner of the said
county, upon the view of the body of....Shedrick Thompson................
there lying dead. I hereby find that the said Shedrick Thompson
came to his death on or about the 20th day of July, 1932, by
hanging himself by the neck.

Dr. George Davis, county coroner, ruled that Shedrick Thompson committed suicide. *Author's collection.*

However, Davis changed his account when describing the crucial hours after the discovery of Thompson's body. In the days following the discovery, Davis talked to a reporter from the *Northern Virginia Daily*, a

newspaper published in nearby Strasburg. In that story, headlined, "County Coroner Reiterates His Verdict," Davis said that he based the suicide verdict on the testimony of Pearson, Sheriff Woolf's deputy. Pearson arrived at the scene before the mob and was able to examine Thompson's body before the crowd set fire to it, he said. Pearson reported to Davis that the stomach and abdomen were in perfect condition, with no evidence of castration, and that Thompson's hands were untied. "Surely the man's hands would have been tied had he been lynched," Davis said. Also, Davis told the newspaper that he had possession of Thompson's skull and that there were no bullet holes in it or "any indication of rough treatment."[101]

Davis offered a different version two weeks later, putting himself at the scene. When talking to Roy Flannagan, reporter for the *(Richmond) News Leader*, Davis did not mention Deputy Pearson. He said that he himself went to the hanging site, arriving before the crowd got there. He said that he was the one who examined Thompson's body and that he made the examination "at leisure." Davis repeated to Flannagan what he said earlier, that Thompson had not been shot, his clothing was not disarranged, his hands and feet were not bound and his body was not mutilated before death. Davis was confident that if Thompson had been lynched, he would have seen some evidence of it. "Nobody hanged him," he concluded. "He hanged himself and for good reason."[102]

The date of death of July 20 meant that Thompson died three days after he assaulted the Baxleys. It's not clear how Davis chose that date. It was a surprising detail, however, and may have revealed more than he intended. Did Davis and other Fauquier officials know before the discovery of the body that Thompson was already dead? Had they learned that a posse had captured and killed him soon after the attack and that his body was somewhere on the mountain? If so, Davis was ready with an explanation of Thompson's death that did not involve lynching. He was certain and offered specific details when he announced his suicide verdict. It was the ending that everyone wanted.

Chapter 6

SUICIDE DOUBTED

D r. Davis ruled that Thompson committed suicide, but Fauquier residents disagreed, and newspapers throughout Virginia challenged the verdict. The decision was seen by many as a rush to judgment, an attempt by officials to cleanse the community of any responsibility for Thompson's death.

One published report noted that a posse of six men, armed with "knives, picks, shotguns, ropes and mowing blades," captured Thompson in an orchard on Rattlesnake Mountain and immediately strung him up.[103] The *Evening Star*, a daily newspaper in Washington, reported that Thompson had a bullet hole in his head. The wounds occurred before the body was torched, the *Star* reported. Its story was headlined, "Suicide Doubted in Death of Man."[104] The *(Richmond) News Leader* called for a new investigation, saying that Virginia is a state "that protects even the worst criminal from the madness of the mob." "The case is certainly not to be written down as a lynching unless positive evidence is forthcoming," the paper added. "Negroes, however, very rarely commit suicide, and persons who find a dead body hanging from a tree in the woods are not apt to set fire to it before notifying the sheriff."[105]

Soon other newspapers joined the protest. The *(Norfolk) Journal and Guide*, a black-owned paper, asked, "If this is a suicide, what's a lynching?"[106] The *Chicago Defender*, the nation's most influential black newspaper, declared in a headline that "Suicide Is Now Synonymous with Lynching in Va."[107] The *Northern Virginia Daily* called on authorities to arrest those responsible for burning the body, calling it a "ghoulish and futile" act. "To sanction such

SUICIDE IS DOUBTED IN NEGRO'S HANGING

Indications Are That The Man Had Been Shot In The Head; Body Mutilated To Some Extent

Doubt is being expressed here as well as in that section of Virginia where the body of Shadrack Thompson, Warren county (Va.) negro, at one time residing here, as to whether the man committed suicide. As stated in this paper last week Thompson's decomposing body was found dangling from a rope to a tree in an old apple orchard near Linden, Warren county, Va.

The *Martinsburg (WV) Journal* was one of the newspapers that questioned the coroner's ruling of suicide in the Thompson case. *Author's collection.*

acts is to invite their recurrence," the paper noted.[108] Three years later, the *Richmond Planet*, a black paper, when recounting Thompson's death, said, "Virginia accepted this strange [suicide] verdict despite the fact that the circumstances surrounding the case made such a conclusion incredible."

In West Virginia, those who knew Thompson told the *Martinsburg Journal* that they did not agree with the suicide verdict. "The authorities' presumption that the man feared capture and took his own life is not generally believed in that section," the paper reported. "There is a tendency to think unidentified parties captured the negro and proceeded with the execution without waiting for the formality of a legal trial."[109] And in Lowell, Massachusetts, the *Courier-Citizen* described Thompson's death as an example of a new type

of lynching: a private affair rather than a public spectacle. "The indications certainly point to a lynching, but if there was such a crime, it was not accompanied by the usual publicity. It seems probable that some of the men who were pursuing him with the legitimate original purpose of securing his arrest, found him and decided to hang him on the spot instead of delivering him over to the law," the paper said.[110]

Roy Flannagan, reporter for the *News Leader*, said after the discovery of the body that he counted fifteen reports by residents who bragged that Thompson had been lynched but that he could not confirm any of the stories. This notion that Thompson "got what he deserved" is apparent in the coverage of the *Fauquier Democrat*, the twice-weekly, eight-page county newspaper. The discovery of Thompson's body and its destruction by the mob were newsworthy events throughout the region. Many newspapers featured both aspects of the incident—the discovery and the burning—in front-page stories. For example, the *Evening Star* in Washington said, "Attacker of Two Is Found Hanging; and Body Burned." The *Northern Virginia Daily* in nearby Strasburg reported, "Fauquier Mob Burns Body of Negro Who Attacked Baxleys." And the *Warren Sentinel* in Front Royal said in its headline, "Crowd Burns Negro's Body." For the *Fauquier Democrat*, however, the actions of the mob were almost an afterthought. The paper's headlines and front-page story focused on the discovery of the body, its identification as Thompson and the belief by authorities that the fugitive had killed himself. One sentence described the actions of the mob, saying that "some people got there and set fire to the swinging decomposed body."[111]

The following week, in his column, "In the Town and Out in the County," Thomas Frank, editor and general manager of the paper, congratulated Sheriff Woolf and others for their role in Thompson's capture and death. It was an unexpected commendation, since Frank is the only writer to directly connect Woolf with Thompson's end. He wrote, "[Thompson] was brought to justice and suffered the death penalty by reason of the untiring and unflagging efforts of the sheriff and his assistants. We think they are entitled to a great deal of credit."[112]

The *News Leader* reported that these boasts gained such credence that county officials felt compelled to follow up on Sheriff Woolf's promise of an investigation. They brought in a judge from outside the county and summoned a special grand jury, a panel of five volunteers charged with determining the cause and manner of Thompson's death. The grand jurors were A.C. Reid, H.I. Hutton, S.M. Read, G.R. Thompson and G.L. Ficklin.

John Peyton DeButts (right) and Earl DeButts. *Courtesy of Tom Davenport.*

Local officials also knew that if they didn't act, the state could enter the case. The state anti-lynching law, passed in 1928, specifically outlawed lynching. The law had rarely been used, but it noted that the state did not have to wait for an invitation from the locality. The state attorney general could intervene in the case of a suspected lynching, and the law provided funds to pay for an investigation.

The special grand jury, led by Judge J.R.H. Alexander of Leesburg, met in Warrenton on October 3, about two weeks after the discovery of Thompson's body. The jurors heard from Dr. George Davis, the coroner; Noah Kenney, the man who found Thompson's body; Henry Baxley; and Deputy W.W. Pearson. They also issued subpoenas to Saffell Nichols, Will Dodson, L.L. Triplett, James Fletcher, John Royston and Carlyle DeButts. Dodson, DeButts and his brother, John Addison DeButts, were suspected of lynching Thompson, and their names have long been associated with the event. Even so, the grand jury did not indict anyone. It ruled that Thompson had committed suicide, noting that it "could find no evidence as to who burned his body"—this despite the fact that Deputy Pearson was there.[113] No one in Fauquier was ever charged with Thompson's death or with the destruction of his body. County officials found refuge in silence and inaction.

Legal scholars have noted that this reaction is typical after a lynching, even though the lynchers were usually known. James H. Chadbourn found that from 1900 to 1930, less than 1 percent of lynchings in the United States were followed by conviction of the lynchers. In Virginia, the number was 4 percent.[114] Lisa Lindquist-Dorr, in her history of black-on-white rape in Virginia, has noted that the Thompson verdict seemed to say that state and local officials would tolerate lynching as long as the mob didn't make a spectacle of it or attract national condemnation.[115]

As Arthur F. Raper, research secretary for the Commission on Interracial Cooperation, an Atlanta-based anti-lynching group, noted, "It is obvious that in most communities where lynching occurs, it is not considered a crime by public opinion or by the courts; state laws against murder, riot, assault and abduction go for naught when lynchers are the offenders."[116] Raper studied the lynchings that occurred in the United States during the first half of the 1930s and listed Thompson as one of eight lynch victims for 1932.

Some greeted the grand jury's suicide verdict with skepticism, but the ruling found an ally in Flannagan, the *News Leader* reporter. Flannagan had been with the paper for nine years, and he also served as campaign manager for former governor Byrd in his 1932 campaign for the presidency and as an aide to Governor John Pollard. Newspapers today would not allow their reporters

to work for two of the state's most influential politicians. However, the *News Leader*, in 1932, was not troubled by this conflict of interest.

The newspaper sent Flannagan to Fauquier to investigate Thompson's death. But his relationship with Byrd calls into question the real purpose of his visit. Byrd was at the time a candidate for national office and had boasted of Virginia's spotless record of lynchings since passage of anti-lynching legislation. It is possible that Byrd recognized that a lynching near his home was a threat to his record and reputation and that Flannagan was his "fixer," assigned to clean up the mess.

Flannagan arrived in Warrenton, the county seat, about one week after the grand jury decision. "I went to Fauquier County firmly convinced that this man had been lynched," he

Roy C. Flannagan. *Courtesy of Virginia Historical Society.*

wrote later in a letter to Walter White, head of the National Association for the Advancement of Colored People (NAACP) in New York. "I returned just as firmly convinced that he had not been. My inquiry was made at considerable trouble and expense for the purpose of forcing official action if there was the slightest evidence of a lynching. We thought that it might have been a case in which local authorities had sought to whitewash the facts. We changed our mind completely after a study of the situation."[117]

Flannagan, thirty-five, was from one of the oldest families in Virginia, a graduate of the University of Virginia and a pilot during World War I. He also was a successful novelist. By 1932, the time of the incident in Fauquier, he had published two novels, *The Whipping* and *Amber Satyr*. But it was his third novel, *County Court*, published in 1937, that may give insight into his thinking about the people of Warrenton and Fauquier. *County Court* is a fictional account of a murder trial in a small town in rural Virginia. In it, Flannagan wrote about the decline of small, agricultural communities

throughout the South and blamed slavery for the decline. "Black labor had offered devastating competition to independent white farmers," he wrote. "So that wave after wave of yeomanry had moved westward, leaving behind them the residue, the unambitious weaklings of their families. The remainder, more feeble in mind and of spirit than in body, had bred others even weaker."[118]

In Warrenton, Flannagan said that he spent four days, "interviewing crackerbox liars and fishing with village Rip Van Winkles who launched the lynching stories." He made no mention of visiting the Markham-Hume area in the northern part of the county, where the attack occurred and where Thompson died. Flannagan also said that none of these lynching reports surfaced until after the discovery of Thompson's body. "This fact sustains a strong presumption that he was not lynched, despite the tall tales. Not even a small lynching gang could have kept such a secret, particularly while the fugitive was being sought everywhere in the hills," he wrote to White. He added that the hanging rope "was part of the line the Negro had used to tie the woman he had abused, and was so short that only a suicide would have thought of using it." Flannagan also noted, "The county authorities should have protected the man's body from those hoodlums and had they done their duty in this regard, there would have been no lynching stories at all."

He added, "The man had every reason to kill himself. He was being hunted like a fox with no means of finding food, and no family, not even a Negro family, would have helped him because of the atrocious nature of his crime. All of the farm houses scattered through this area are guarded by dogs and there was no way he could steal food." Flannagan concluded that a verdict of lynching in the Thompson case "is plainly an injustice" to Virginia. He said that the state was as determined to end lynching as it was forty years earlier when it brought an end to dueling.

In the front-page story he wrote about Thompson, Flannagan reported that the "crazed Negro, after the horrible crime he committed, and after being the fugitive in the most savage man chase in the history of the county, hanged himself." Flannagan's story relied chiefly on the "uncontroverted and expert testimony" of Dr. Davis, the coroner, a "man of absolutely unimpeachable integrity."[119]

But several national civil rights organizations did not share Flannagan's conviction. They believed that the incident had all the markings of a murder. Organizations such as the Federal Council of Churches and Tuskegee Normal and Training Institute in Alabama compiled annual lists of people

who had been lynched. The lists included the names of the victims and the dates and localities in which they died. The organizations hoped that by documenting lynch deaths they could help end the practice or, as Robert Russa Moton, president of Tuskegee, said, "shock all good citizens" into action.[120] Indeed, the efforts of the organizations and other factors had helped reduce the incidence of lynching since 1900.

When the 1932 lists started appearing in December, Thompson's name was on them. The NAACP, the Associated Negro Press, Tuskegee, the Federal Council of Churches and the *Chicago Defender* were among the organizations arguing that Thompson had been lynched. Each defined lynching in its own way, so they did not agree on the total number of deaths nationwide. Tuskegee and the Council of Churches, for example, said that eight people were lynched in 1932, while the League of Struggle for Negro Rights counted thirty-seven victims. The NAACP and the Associated Negro Press each counted eleven victims, although only eight individuals appeared on both of their lists. Even so, all the groups counted Thompson. They dismissed the official ruling of suicide from Dr. Davis and the special grand jury. They said Thompson's death was a mob murder.[121]

But it was the NAACP's list for 1932, published at year's end, that most bothered former governor Byrd and other state officials. Byrd spent the Christmas holidays asking friends to lobby the NAACP to get Thompson removed from its list. Byrd wrote a flurry of letters, including one to George F. Milton, editor of the *Chattanooga News* in Tennessee. Milton was also chairman of the Southern Commission on the Study of Lynching and had once described lynching as "naught other than a relapse into the jungle era of man's development."[122] Byrd told Milton that he was familiar with the case in Fauquier County, and "this is not a lynching, as we can prove by indisputable evidence," although he did not say what that evidence was.[123] Byrd wrote similar letters to Governor Pollard; Douglas Southall Freeman, editor of the *News Leader* in Richmond; and Louis I. Jaffe, editor of the *Virginian-Pilot* newspaper in Norfolk. "Could you in some way reach the NAACP and have them remove from their records the alleged lynching?" he asked Jaffe, who had won a Pulitzer Prize in 1929 for an anti-lynching editorial.[124]

Governor Pollard declined to get involved, but the other three—Milton, Freeman and Jaffe—as well as Flannagan, wrote to White, secretary of the NAACP, on Byrd's behalf. Byrd himself wrote to White, saying, "I investigated the alleged lynching in Fauquier, and I am convinced, as is everyone else that made a similar investigation, that this was not a lynching." Again, he offered no evidence but added, "I trust very much that you will

correct this erroneous record."[125] Virginius Dabney, a staff writer and later editor at the *Richmond Times-Dispatch*, joined Byrd and called on the NAACP to remove "this stain on the name of Virginia" by dropping Thompson's name from its list.[126]

Byrd's opposition to lynching was motivated, in part, by two lynchings that occurred while he was governor. The first happened in August 1926 in Wythe County in southwest Virginia and involved a thirty-one-year-old black farmhand named Raymond Bird. Governor Byrd felt that the sheriff and prosecutor in Wythe had failed to prevent Bird's death or prosecute those responsible, but he found that there was little he could do about it.

Bird had worked for five years on the farm of Grover and Sallie Grubb, a white couple. The Grubbs had four children, including three daughters. When one of his daughters, nineteen-year-old Minnie, gave birth to a child by Bird, Grubb complained to the authorities. Bird was arrested two weeks later and charged with raping Minnie and her twenty-two-year-old sister, Essie May, who also was pregnant with Bird's child. Authorities concluded that Bird could not be prosecuted for raping the older girls and dropped those charges, but they did charge him with attempted assault for trying to fondle the other Grubb girl, a twelve-year-old. Bird was taken to the Wytheville jail, where a mob of fifty men arrived in the middle of the night to demand at the point of a shotgun that the jailer give them the keys to his cell. The men were armed and masked, and many wore costumes, including dresses. Bird was asleep when the men arrived. They shot him, battered his skull, pulled him from the jail and tied him by the neck to the running board of a car and then dragged him nine miles to a spot near the Grubb farm, where they hanged him. The day after the lynching, Governor Byrd called the commonwealth's attorney in Wythe to offer the state's help, but he was told that all was quiet and that county authorities were doing their own investigation. One person was eventually charged with Bird's murder, but a jury found him not guilty.[127]

Soon after, in 1927, came the lynching of Leonard Woods. Woods, a black man, was in jail in Whitesburg, Kentucky, charged with killing a white man in Virginia. As in the Bird case, a mob arrived at the jail in the middle of the night, stormed the building and took Woods. The mob, estimated at three hundred people, drove to the state line between Jenkins, Kentucky, and Norton, Virginia. They stopped at a platform that had been used days earlier for the dedication of a new highway between the two states. There they hanged and shot Woods, used the wooden platform to construct a pyre and burned the body.[128]

Because of the two deaths and the criticism that followed, Governor Byrd asked the General Assembly to pass anti-lynching legislation. The law made lynchings a concern of the state as well as the localities. It held that if a suspected lynching occurred, local officials "shall promptly and diligently" identify those responsible and prosecute them. But it also allowed the state attorney general to intervene, and it permitted the governor to spend any money necessary to identify and apprehend the members of a lynch mob. The law also guaranteed the accused lynchers the right to be tried in the locality in which the alleged crime was committed, which limited its effectiveness. Byrd would later boast that the law was the "most drastic anti-lynching law ever passed by any southern state," but no white person was ever convicted under the statute of lynching a black person.[129] Byrd also claimed that Virginia had had no lynchings since passage of the law, so his defense of the suicide verdict in the Thompson case was understandable. "We do not want to be charged with a lynching that did not occur," he wrote to a friend.[130]

Byrd advocated for the anti-lynching law more out of a concern for Virginia's reputation than for the well-being of its black citizens. Virginia was the last state where lynching should be tolerated, he said, since "Virginians contributed to America the leaders who taught that this was a government by laws." He also believed that lynching discouraged new capital from moving to the state and hindered industrial development. In short, lynching was bad for business.[131]

Byrd also was concerned about his political future. In 1932, he enjoyed national attention as he sought the U.S. presidency. In January, the Virginia General Assembly backed his candidacy, followed by the state's congressional delegation. A Virginia Byrd Committee was formed that spring, chaired by Governor Pollard and managed by Flannagan, the reporter. The committee mailed out biographical sketches of Byrd and reprints of favorable editorials.[132] At the Democratic National Convention in Chicago in late June, Byrd's name was placed in nomination for president. He received votes on three ballots before the convention chose Franklin Roosevelt. Byrd was also mentioned as a vice presidential candidate, but Roosevelt selected John Nance Garner, a Texas congressman who was then speaker of the U.S. House of Representatives. With unemployment at 20 percent, Roosevelt easily defeated Herbert Hoover, the incumbent, in the November election, carrying forty-two states; 80 percent of Fauquier voters chose Roosevelt, and the county joined Virginia and the nation in giving him the landslide victory.

So when Byrd's letters and those of his allies arrived at the NAACP, condemning its lynching decision in the Thompson case, White had to listen. White, thirty-nine, documented the history of lynching in his book *Rope and Faggot: A Biography of Judge Lynch*. He was light-skinned and could pass for white, and he had worked undercover for the NAACP in the South, investigating lynchings. He had assumed the top spot in the organization in 1931 after working there for thirteen years. At first, he defended the NAACP, saying that the decision was based, in part, on press coverage of Thompson's death. He cited specifically a September 20 editorial in the *News Leader*, which criticized Dr. Davis's ruling of suicide and called for a new inquiry. The NAACP also relied on inquiries that it made of unnamed "white and colored people," White said. "Careful consideration of these facts seemed to clearly indicate that Thompson had been lynched," White wrote to Freeman.[133] As for the official verdict of suicide, White rejected it, saying to Milton, "There seemed no proof of this fact, and since also it is a rare thing for a Negro in a rural community to commit suicide, we felt justified in listing this as a lynching."[134]

In writing to Byrd in January 1933, White was more conciliatory than he had been to Milton and Freeman. He told Byrd that "all evidence seemed definitely to point towards it being a lynching." But he also conceded that

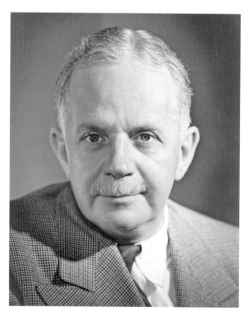

Thompson's death was a "hairline" case. Even so, he said he believed that Thompson was murdered, since there was no evidence to support the suicide theory and since the mob went to the trouble of burning the body.[135] During this flurry of correspondence, White asked James H. Dillard, a white friend and Charlottesville, Virginia attorney, for his advice. Dillard replied, "Personally I am convinced it was a lynching." Three weeks later, Dillard wrote to White again about Thompson's death. "The gentlemen who write so emphatically of their conviction

Walter White. *Courtesy of Library of Congress.*

that the case was not a lynching do not in their letters give very distinctly the ground of this conviction."

Dillard added, "I suppose the problem of the death of Shadrock Thompson will always remain unsolved. If Sherlock Holmes could be brought back to life, and live quietly six months in Warrenton, perhaps he could throw some light. But I know of no other way." He repeated his earlier belief: "From all I have been able to read about this unfortunate case, I cannot keep from believing that Thompson was lynched." But then he offered White an escape, perhaps telling him what he wanted to hear: "In view of the letters from Mr. Flannagan and Governor Byrd, my advice would be to report the case as a doubtful one."[136]

Soon after hearing from Dillard, White softened his stance. In January 1933, when the NAACP published its *Twenty-third Annual Report*, for 1932, he removed Thompson's name from its list of lynch victims. In a special note in the report, White described the Thompson case as one "in which there was much controversy." He described how the organization announced in late 1932 that it would list Thompson as a lynch victim and how "upon publication of this statement numerous protests were made to the effect that the case was one of suicide." White also said that "Governor Harry F. Byrd of Virginia was strong in his protest that this was not a lynching. Independent investigations, some by experienced newspaper men, support to a degree the suicide theory." White concluded, "Since this seemed to be a 'hairline' case it is not included in the Association's Lynching Record for 1932."[137]

Byrd and others also pressured the Tuskegee Institute in Alabama to keep Thompson's name from its 1932 lynch list. The *News Leader* reported in October that Dr. Robert Russa Moton,

Robert Russa Moton. *Courtesy of Tuskegee University Archives.*

principal of Tuskegee, was making inquiries about the Thompson case. The paper sent Moton a copy of Flannagan's story, and Moton said he would study all the available evidence.[138] Two months later, he placed Thompson's name on Tuskegee's list, and unlike Walter White at the NAACP, he never removed it. To Moton, the indifference, even the complicity, of county officials at the time of the discovery of the body was more important than the theories offered afterward. "The coroner was immediately notified and viewed the body," Moton wrote. "Thompson's body, therefore, came into the hands of the law. The law, however, did not retain possession of it, but permitted it to come into the hands of the mob, which burned the body, distributed Thompson's teeth as souvenirs and placed his head on exhibition in the town of Warrenton."[139]

Chapter 7

WILLING TO USE VIOLENCE

Tuskegee's decision to list Thompson's death as a lynching meant the continuation of a curious trend for Virginia. The state had gone eight years without a lynching, from 1910 to 1917. Then, Virginia residents revived the ritual with lynchings in Northumberland County ('17), Pittsylvania County ('17), Culpeper County ('18), Wise County ('20), Brunswick County ('21), King William County ('23), Sussex County ('25), Wythe County ('26) and again in Wise ('27).[140]

It's not clear why this revival took place, but it produced an annual lynching rate for Virginia not seen since the 1880s and 1890s, some thirty years earlier, when Virginia residents and their neighbors throughout the South regularly resorted to mob violence.[141] Even though lynchings occurred in all parts of the United States in the nineteenth and twentieth centuries, no region matched the South for its ferocity. One of the first lynching studies, done by the National Association for the Advancement of Colored People in 1919, found that 88 percent of all lynchings in the United States occurred in the South and that almost 80 percent of lynch victims were black.[142] Historians do not agree on how many people were killed during the worst of the lynch mania. Numbers differ, depending on the states studied, the years included and the way lynching was defined. What is certain, however, is that mob murder was a feature of the southern landscape for decades and that it resulted in the deaths of thousands of people. Sociologists Stewart E. Tolnay and E.M. Beck, two of the most frequently cited researchers, list more than 2,800 lynching victims, including more than 2,400 black people.

"On average, a black man, woman or child was murdered nearly once a week, every week, between 1882 and 1930 by a hate-driven white mob," they concluded.[143]

Historians note that tabulations such as these probably underestimated the death toll. Many blacks disappeared or were killed during this period, and their deaths went unreported. In fact, the latest lynching study, conducted in 2015 by the Equal Justice Initiative, a Montgomery, Alabama civil rights law firm, found 3,959 black lynch victims in twelve southern states between 1877 and 1950. Staff members counted the most notorious incidents, including those described in regional newspaper accounts, and those identified by Tolnay and Beck, the Tuskegee Institute and other researchers. But they also spent five years visiting 170 southern communities, where they talked to local residents and searched local archives. They found an additional 700 lynch deaths that had not been widely reported or counted.[144] At first, the Equal Justice Initiative did not include Thompson in its count of lynch victims. However, at the request of the author of this book, a staff attorney for the firm reviewed material from the Thompson case and added his name to its list.

Lynching can be seen as but one aspect of the long and troubled relationship between whites and blacks in America, a point on a continuum that stretches from the importation of twenty African slaves at Jamestown, Virginia, in 1619, through the Civil War and liberation, through disenfranchisement and Jim Crow, to segregation and civil rights and down to the present-day conflicts involving black communities and the police. In Virginia and throughout the South and the nation, this relationship evolved into two societies, one white and one black, separate and often unequal. To W.E.B. Du Bois, the historian and one of the founders of the NAACP, these two societies were "double stars, bound for all time."[145]

And as happened in the lynching years, whites were willing to use violence against blacks to instill fear and maintain control. Lynching is defined as premeditated mob murder or death at the hands of a group of three or more people who are acting under pretext of enforcing justice or protecting social order.[146] The lynch victim was usually put to death by hanging, although shooting, beating and drowning also were used. About 80 percent of those lynched were accused of felonies, such as murder, rape and assault. But hundreds of others were murdered for offenses such as suing a white man, trying to vote or using obscene language.[147] In Georgia after World War I, a mob lynched a returning black veteran when he refused its warning and continued to wear his army uniform.[148]

Tolnay listed four reasons why whites resorted to lynching: to kill those accused of crimes; to maintain white dominance; to eliminate black competition for social, political or economic rewards; and to encourage white unity.[149] Some historians describe lynching as community spectacle or theater, and other researchers, such as Orlando Patterson, have compared it to religious rituals of human sacrifice.[150] Most agree that it was primarily a form of homegrown terrorism, extraordinary evil practiced by ordinary people in an attempt to maintain social control over their newly freed neighbors.

Estimates vary on exactly how many black people were lynched in Virginia. The NAACP put the number of black lynch deaths in Virginia from 1889 to 1918 at seventy-eight.[151] Later historians, such as W. Fitzhugh Brundage, started with the work of the NAACP, corrected for the errors found and published what they believed were more accurate numbers. Brundage counted seventy-one black lynch deaths in Virginia for the years 1880 to 1930, or about one every eight months.[152] This total puts Virginia at the bottom of the list of southern states, along with North Carolina. Lynching was never as firmly rooted in Virginia as it was in other southern states. The practice offended the basic character of Virginia, what Brundage described as its "elitist and temperamentally conservative" nature. Virginians revered law and order, he said, and lynching was anything but that. Lynching was anarchy.[153]

Of Virginia's 134 localities, nearly two-thirds had no lynchings. However, Fauquier and a handful of other localities had more than one.[154] Fauquier's first lynching occurred in 1880 and involved a young black farmhand named Arthur Jordan. Jordan was married with two children when he ran off with the seventeen-year-old daughter of his employer, Nathan Corder. Like Jessica in *The Merchant of Venice*, Miss Corder robbed her father in addition to eloping, stealing $1,000 from him. Eight horsemen, "heavily armed and equipped," according to one news account, set off from Warrenton in search of the runaway couple. They tracked them for several days, across the Potomac River, before finding them in Williamsport, Maryland. The posse apparently knew to look in Williamsport, as the couple was said to have visited the town several times "attracting great attention each time."[155]

The posse captured the pair, left the girl at Taylor's Hotel in the care of the proprietor and his wife and returned to Fauquier with Jordan. On the way home, on Main Street in Winchester, Virginia, Jordan refused to go farther. When the posse tried to whip his horse on, a constable stopped them. The men couldn't produce a warrant, so the constable arrested them and took them before a judge. Black residents of the town learned what was happening and hired a lawyer to represent Jordan. But they were too late.

The judge swore in one of the posse as a special constable, and the men took off. Soon they reached Warrenton and placed Jordan in the jail. That night, a mob of forty to sixty men stormed the jail, took Jordan from his cell and hanged him in the town cemetery. Afterward, a grand jury ruled that Jordan had strangled to death, but it said it was unable to identify his murderers.

It was common throughout the lynching era for coroner's juries to render this type of verdict, or death "at the hands of parties unknown." Historian Robert L. Zangrando has termed these "sham" verdicts since lynchers' identities were seldom a secret. "Public officials, answerable to a white electorate, cooperated with the white mob," Zangrando said.[156]

Fauquier's second incident was rare in the annals of Virginia lynchings because it involved two lynch victims, both white. It began in late 1891 with the murder of four members of the Kines family, including three children. The accused were Lee Heflin and Joseph Dye, farmhands and neighbors of the family, near Calverton. The two knew that Mrs. James Kines, a widow, kept money in the house, and Heflin went there to rob her. When Mrs. Kines refused to hand over the money, Heflin murdered her and her three children, daughters Lizzie and Annie and son Gilbert, ages four, seven and eleven, respectively. He returned the next day and set fire to the house to eliminate evidence of his crime.

Lee Heflin (left) and Joseph Dye. *Courtesy of Fauquier Historical Society.*

Months later, during Heflin's trial in the county courthouse in Warrenton, a local newspaper reported, "It is impossible to exaggerate the intenseness of the feeling in this case, which increases rather than abates as time passes."[157] At one point during the trial, loud cries and threats from the crowd could be heard outside the courthouse. The doors burst open, and "the shouting crowd pressed inward, while those inside sprang to their feet to repel the invasion," according to one account.[158] The crowd was intent on capturing Heflin, but a detective hopped on a chair and held up a cocked pistol. "For several moments the wildest excitement prevailed, but gradually order was restored and the door secured," one newspaper said.[159] Later, so many people attended the trial that a special guard had to be appointed to keep them away from Heflin, and there were fears that the courtroom floor would buckle. "The eagerness of the crowd is indescribable, and it is the largest ever seen in the courthouse," one report noted.[160]

Heflin was eventually convicted of murder, as was Dye, who was said to have planned the murders. Both men were sentenced to be hanged. But in March 1892, on the day they were to be executed, Governor Philip McKinney granted a stay. "This angered the citizens of Warrenton, and all day yesterday, small knots of resolute looking men congregated on the street corner and angrily discussed the matter," a newspaper reported.[161] Authorities hoped to save the pair from the mob and decided to secretly move them to the jail in Alexandria. The two were handcuffed and placed in a covered wagon with a four-man guard. The caravan left in the dark, with snow and sleet falling, headed to Gainesville, where they were to board a train. A mob of sixty Fauquier residents, masked and armed with revolvers and Winchester rifles, stormed the Warrenton jail about midnight, only to find the prisoners gone. The men overtook the wagon about two miles outside Gainesville in Prince William County, where the guards surrendered their prisoners.

The men took the prisoners to a spot at the edge of the woods, about one hundred yards from the road. Dye was the first to die. They placed a noose around his neck and hoisted him from a cedar tree. The tree limb broke under his weight, so the men chose another limb from the same tree and pulled him up until his feet were about one foot off the ground.[162] Dye gasped and kicked wildly as he slowly strangled. The mob fired their guns at him, and soon he hung limp. Later, someone counted eight bullet holes in him. Heflin watched his partner die, and then someone shouted, "Up with him." Soon he swung from an adjoining tree. Like Dye, Heflin struggled for breath and then died under a volley of four shots. A coroner's

jury met the next morning, while the bodies were still hanging from the trees. It decided that the men died from hanging and pistol shots at the hands of "persons unknown."

Ten years later, Joseph Arthur Jeffries, a Fauquier resident, defended the lynching of Heflin and Dye and, in doing so, may have shed light on the thinking of the men who lynched Thompson. Jeffries ran a pharmacy in Warrenton and was a frequent contributor to the local newspapers. In one letter to the editor titled "Why Lynchings?" he wrote of the unreliability of the local courts and the shrewdness and "criminal wickedness" of the local defense attorneys. This combination made swift justice for even the "vilest of criminals impossible," he said. Jeffries concluded, "If this [lynching] is a crime, where lay the blame? This juggling with justice is only one of many like it throughout our land. When we have our criminal laws clear, swift, and effective and when we have our judiciary learned, clean, and of courage to enforce them, then and only then, shall we be free from these mob troubles that bring the blush of shame to the cheeks of our best people and disgrace us in the eyes of the civilized world."[163]

Chapter 8

DEATH ON RATTLESNAKE MOUNTAIN

The lynchings of Heflin and Dye were typical of many at the time in the sense that they were a form of community theater, planned and publicized in advance and staged in public for maximum effect. During the worst of the lynch era, at the end of the nineteenth century and the beginning of the twentieth century, lynchings occurred beside busy roads, at schools or on street corners. In 1893, outside Winchester, Virginia, about forty miles from Rattlesnake Mountain, a mob seized William Shorter, accused of attempted rape. They took him from the sheriff on a crowded train and lynched him beside the track in view of all the passengers. Lynching was done to intimidate and terrorize, and a public lynching was the best way to do that.

In many ways, Thompson's death forty years later mirrored the deaths of Heflin and Dye. Both incidents began as violent crimes and featured private executions and a failure of the criminal justice system to assign responsibility. Thompson's death had many other elements of the old way: the ritual of torture, the defilement and burning of the body, the collection of body parts as souvenirs and the absence of remorse. It also featured the type of retaliation that occurred during the lynch era after cases of alleged sexual assault.

But Thompson's death also typified a new kind of lynching, a change in its form. Thompson's death was private and small-scale, cloaked in silence and mystery, an example of what historian Philip Dray called an "underground lynching." The shift came early in the twentieth century, as public attitudes

changed and the prosecution of lynchers became a possibility. "Death was meted out to a victim in a swift, assured manner by men who knew better than to call attention to their act, and who relied on the code of silence in rural communities to evade prosecution," Dray said.[164]

The League of Struggle for Negro Rights noted this silence about Thompson's death when it included him on its 1932 list of lynch victims. "There was a definite attempt [in 1932] to cover up many lynchings," it said. "In many cases the lynchers did their work quietly and discovery was made only much later." The organization offered two reasons for this secrecy: an increased militancy on the part of blacks and whites and the realization by those who did the lynching that they no longer had the support of the majority of whites.[165]

And so Thompson's body remained in the apple tree for nearly two months, becoming, as Billie Holiday sings, "fruit for the crows to pluck…a strange and bitter crop."[166] By removing Thompson's name from its 1932 lynch list, the NAACP gave Governor Byrd and his supporters what they wanted. They could continue to say that Thompson committed suicide and that lynching ended in the Old Dominion with the death of Leonard Woods and the passage of the state's anti-lynching law in 1928. They could claim that Virginia was unlike other southern states, where lynching lived at least another twenty years.

Virginius Dabney made this claim in 1937 when he wrote that a change had come over the South. Federal anti-lynching legislation was being debated in Congress, he wrote, yet there was little worry about it in Dixie. Large numbers of southerners either favored the law or were willing to give it a try, he wrote. In fact, his native Virginia already had a strong anti-lynching law, Dabney said, and "there has not been a lynching in the state since the law was passed in 1928."

Dabney, a historian and longtime editor of the *Richmond Times-Dispatch* newspaper, wrote about Virginia's lynching history in a piece titled "Dixie Rejects Lynching" for the *Nation* magazine.[167] He was not the last to make this claim. Louis Jaffe, editor of the *Virginian-Pilot* newspaper in Norfolk, received the Pulitzer Prize in 1929 for his anti-lynching editorials and his advocacy for the state's anti-lynching law. Jaffe called the law "an epochal measure" and was proud that no lynchings had taken place in the state after its passage.[168]

Paul Beers, writing about the lynching of Raymond Bird in Wythe County in 1926, called Bird's death the "last documented lynching in Virginia." Beers, an attorney and historian, repeated Dabney's claim about the

effectiveness of the anti-lynching law and added, "Nearly all other students of Virginia lynching agree with Dabney's conclusion."[169] In Fauquier, too, the Thompson case is absent from county histories. One example is Marylin Rumph's account of the lynching of Heflin and Dye, which is described as the "Last Mob Lynching in Fauquier County."[170]

There is no record that former governor Byrd ever read the *Nation* article, but he certainly would have agreed with Dabney's claim. And he would have been pleased with how it has been repeated ever since. It was exactly what Byrd had in mind during the Christmas holidays in 1932, when he worked so hard to have Thompson's death ruled a suicide.

But others believe that the Thompson case gives lie to the claim that Virginians stopped lynching. Historians J. Douglas Smith and Lisa Lindquist-Dorr cited Thompson's death as an example of how the anti-lynching law received more credit that it deserved. In his *Managing White Supremacy: Race, Politics, and Citizenship in Jim Crow Virginia*, Smith noted that state boosters praised the law for putting an end to lynching in Virginia. Yet with the Thompson case, he said, Fauquier residents "turned to the suicide explanation as a means of avoiding a charge of lynching."[171] Dorr, in her *White Women, Rape, and the Power of Race in Virginia, 1900–1960*, said that the Thompson case showed that Virginia residents had not given up "extralegal justice entirely."[172]

Ronald Heinemann, in his biography of Harry Byrd, called Thompson's death a "likely" lynching.[173] "Clearly, something had happened, serious enough in nature, to warrant Byrd's interest," he said.[174] And in 1970, the late Charles Perdue, who wrote several Depression-era books about Virginia, interviewed about a dozen Fauquier residents, black and white, about the Thompson incident. His informants included the daughter of Dr. George Davis, the county coroner, and members of the posse who hunted Thompson. Purdue concluded, "The only thing in common in all the stories is that a black man had sexual relations with a white woman and that he died at the end of a rope. It does seem exceedingly unlikely that he would have been able to do all the damage to himself that it was claimed he suffered and then lynch himself."[175]

Arthur F. Raper of the Commission on Interracial Cooperation counted eighty-four lynchings nationwide committed during the period from 1931 to 1935. He included Thompson in his study. "The optimism of 10 years ago is waning; lynchings are not fading naturally from the American scene; the mob still rules," Raper wrote.[176] The Thompson case fit Raper's description of the typical lynching during this period, in that it involved a black victim

and took place in a poor, rural locality in the South. In addition, those responsible for it were native-born whites and were not indicted, convicted or imprisoned. Rape, one of the accusations against Thompson, was alleged in 11 percent of the cases in Raper's study. "Local civilization has broken down when a mob forms," Raper concluded. "And there is no substitute for local civilization."[177]

Few were as outspoken in their criticism of the Thompson case as M.A. Norrell, editor of the *Richmond Planet,* a black newspaper. "This suicide yarn has been overworked in Warrenton and vicinity," Norrell wrote. "Virginia may stand by and in self complacency assert that the Byrd law precludes lynching in this state. Better to face the ugly fact, accept the disgrace and enforce the Byrd law than to attempt to evade the issue by setting forth this unbelievable suicide defense."[178]

Current residents of Fauquier know of no photos, letters, diaries or records that prove that Thompson was lynched. But they cite the local lore, the stories they've been told, combined with a logic born of time and place. As Alphonso Washington, the black preacher who was a teenage houseboy at the Cove on the night of the attack, observed, "White people did whatever they wanted to do to black folks in those days."[179] The Association of Southern Women for the Prevention of Lynching, an Atlanta-based group of white women, reached a similar conclusion when it placed Thompson on its 1932 list of lynch victims. "If a black man dies under mysterious circumstances in the rural South, one is justified in thinking the worst," it said. In other words, given the history of race relations in the region, if it looks like a lynching, it probably was.[180]

In reflecting on Thompson's death, Jeff Urbanski, who lives in the shadow of Rattlesnake Mountain and whose great-uncles have been implicated in the crime, said that he finds it hard to talk about the incident out of loyalty to his family. However, he said he disagrees with what happened and recognizes it as part of Fauquier's blemished past. "I think emotions ruled," he said. "They caught him, and they exacted justice right there, and they walked away."[181] Urbanski's great-uncles Carlyle and John Addison DeButts are frequently mentioned as participants in the lynch party. Urbanski disputed the claim that they were its leaders. "I can't imagine my uncles being the leaders of anything," he said.[182]

Henry Baxley Jr., who was in the house when Thompson attacked his parents, tells the same story. "It was never ruled as a lynching, but everybody knows that it was. It was fairly well known who did this. The word went around that it was the DeButts boys."[183] Urbanski said that the DeButts

Jeff Urbanski. *Courtesy of Tom Davenport.*

brothers, whose nicknames were "Mote" and "Cocky," never spoke to him about the lynching, although his grandmother, their sister, did talk about it. "I was never, ever led to believe that it was anything other than that. He did the act, he hid in the mountain, he was caught, the mob took care of him and walked away from it," Urbanski said. Urbanski said he understands how, with Thompson at large, the community would have been in an uproar and felt that it had to do something. "You couldn't go about your life if you didn't get this cleaned up," he said.[184]

Other Fauquier residents tell similar stories. "They caught him and burned him and castrated him, up there in that orchard," said Sylvia Gaskins. "They should have let the law take care of it."[185] Gaskins is black, in her eighties and a lifelong resident of Fauquier who grew up on Africa Mountain. Her father, Guy Jackson, was a friend of Thompson's.

Other residents are puzzled by the provocation that led to Thompson's violent assault on the Baxleys. "You want to really know what set him off to do such a thing," said Barbara Herrell, who is white. "By hanging him, you shut him up. Now we'll never know."[186] Herrell said that the hanging tree became a local landmark and that her father, John Herrell, took her brother, David, to see it. "He showed him the big limb where they hung him," she said.

As retold by these residents, the end for Thompson came soon after he attacked the Baxleys, perhaps by Wednesday, the third day after the incident.

Sylvia Gaskins. *Author's collection.*

Barbara Herrell (right) and her sister, Mary. *Courtesy of Tom Davenport.*

"They rode horses days and night. They kept on riding until they found him," said the late Emma Coleman, a black resident of Markham who was thirty-five at the time of the incident.[187] Thompson escaped his pursuers for a while, but according to one frequently told story, he was finally spotted sitting by himself, dressed in a white shirt, on a rock near what was known as the old Johnson place.[188] Armed men with dogs, traveling on foot and horseback, surrounded him, closed the circle and captured him.

Another version had Thompson alone inside a mountain cabin, south of Linden, Virginia, with two pistols at his side. His pursuers watched through the cabin windows while he ate. "They waited until he had the spoon in his hand and putting the food to his mouth and got the drop on him that way," said Doug Hume, a resident of Fauquier and rural mail carrier in the Markham area for thirty-six years.[189] According to this version, Thompson was captured without a shot being fired.

One can suppose that the men bound their quarry to better control him and marched Thompson, pushing and pulling, much as he had done to Mamie Baxley only days earlier. We can see them moving through the mountain trails and hear the sound of their horses' hooves on the stones. They probably would have been a silent group, determined, with no taunting or celebration of Thompson's capture, for theirs was an uncertain task. They had decided on a terrible punishment, one that required them to look Thompson in the eyes and lay hands on him. In addition, they were self-assigned, in violation of the law, and with no guarantee of community support. If Sheriff Woolf had been with them, they would be heading east toward the county jail, not south to the Borden farm. It was best they act quickly.

By their actions, the men also rejected the reward offered for Thompson's capture. Unlike Noah Kenney, who found the body and claimed the reward, only to have his claim denied by the Fauquier Board of Supervisors, these men had captured Thompson alive and earned their payday. Yet the $250 reward, substantial at a time of Depression, was not important to them. What mattered most was vengeance.

Thompson no doubt knew his captors. He was born in Markham and educated there. He was a wage hand who had worked their farms, as had his father and brother. Yet that meant nothing in the end. In news accounts of the incident and in legal documents, Thompson was referred to incorrectly as "Shadrack," "Shad," "Chad," "Shedurek," "Shadr'k," "Shadrick," "Shadrock," "Shadrach" and "Shadric." Nobody seemed to know his given name, Shedrick. He had lived among them most of his life, yet he was invisible. It was as if he were a stranger passing through, a troublemaker

from somewhere else. He had risked his life as a U.S. soldier at war, defending the rule of law, yet he died without benefit of it.

The posse, with Thompson in tow, finally stopped near the fence that marked the property line between Mt. Welby and the Borden place, not far from John DeButts's log home. From this house may have come the rope used to hang Thompson. The hanging rope is a crucial element in the Thompson tale. On the night his body was found, when county authorities offered what was to become the official version of his death, they said the fugitive decided during his desperate flight that he was doomed, and rather than submit to certain execution, he hanged himself. For this theory to work, however, Thompson had to have a rope. The authorities must have realized this, and that night they said that the rope around his neck was "known to have been in his possession." In his story for the *News Leader*, published soon after the discovery of the body, Roy Flannagan reported that Thompson used a rope to bind Mamie Baxley and that the same rope was found later around his neck, although Flannagan was the only one to report that Thompson used a rope during the abduction.[190]

Even so, these details assume that Thompson considered a rope indispensable and had one with him always, from the battering of Henry Baxley in the bedroom at Edenhurst to the abduction of Mamie Baxley and her rape at Locust Shoots, through to his mad dash in the mountains. It seems unlikely, however, that a man fleeing the law, hiding in the forest, foraging for food and water, would worry about a rope. As the *Clifton Forge (VA) Review* noted after the discovery of the body, when it called for a new investigation into Thompson's death, "An individual eluding arrest could not have found the time to locate a piece of rope."[191]

When the posse reached the edge of the DeButts apple orchard, it crossed onto the Borden farm. There they chose a volunteer apple tree, one that had self-seeded and grown up outside the orchard. Since it was mid-July, the tree would have been filled with round, green apples in clumps of four and five. Within its leaves, the men found a sturdy branch. One can picture how they tied a noose in one end of their rope and placed it around Thompson's neck. Noah Kenney said when he found the body, Thompson's feet were dangling two feet off the ground, a pile of stones beneath him. Thompson had apparently been placed on the stones, and then on, someone's command—the last sound he heard—they pulled him off. With that came the groan of the limb. Thompson's face would have filled with blood, followed by a heaving of his shoulders and a convulsive drawing-up of his legs.

Dr. Davis, the coroner, said that the body bore no evidence of mutilation. However, local residents say that Thompson was tortured before death and that he was shot, castrated and had his fingernails pulled out. One account described how the posse made a point of cutting off his testicles and hanging them beside him.[192] "I always heard that they did it all to him," Urbanski said.[193]

The posse watched as Thompson strangled, silently tracking each swing of his body. Finally, there was no struggle. One can imagine that they felt satisfied with the results of their mountain tribunal. Thompson had been made to pay for his crime, and Mamie Baxley had been spared. She would not have to appear in court to describe what happened that Sunday night in July. She would not have to look at Thompson again or listen to his excuses. But the absence of a trial also meant that the reason for the attack would remain forever a secret and that justice would be denied.

The men did not call attention to Thompson's body hanging in the orchard or openly claim responsibility for what they had done. There was probably little celebration as they returned to their homes and farms. Death, always sobering, must have been more so for these men. It was probably the first time that any of them had killed a man.

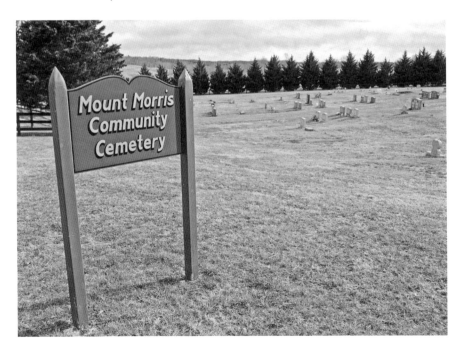

Mount Morris Community Cemetery near Hume. *Author's collection.*

Grover Thompson was Shedrick Thompson's stepson. He is buried at Mount Morris Community Cemetery. *Author's collection.*

There is no record that Thompson's family ever came forward to question the circumstances of his death or to claim his remains. Today, many of the Thompsons are buried at Mount Morris Community Cemetery, the black cemetery near Hume. The family headstone contains the names of Marrington and Fannie, Shedrick's parents. Also listed are his older siblings, Katie and Raymond, and two of the younger ones, Mary and Julia. Ruth Thompson, Shedrick's wife, is also buried there, as is Grover Thompson, Ruth's son. Shedrick is not among them. Apparently, there was not enough of him left to bury.

In March 1933, six months after the discovery of her husband's body, Ruth Thompson applied to the federal government to collect the money due him under the World War Adjusted Compensation Act. Her witnesses on the application were James Jackson, the man who found Mamie Baxley on the morning after Shedrick beat and raped her, and Fannie Thompson, Shedrick's mother. This was the same payment that the Bonus Army had marched for, but like the marchers, Ruth was denied. In her later years, Ruth opened her home to foster children. She never remarried and died alone at her home on Africa Mountain in 1975. She was seventy-seven.

Henry Baxley eventually took over his father-in-law's insurance business in Warrenton. He also was vestryman and treasurer at Leeds Episcopal Church, as his father-in-law had been, chairman of the local school board,

Ruth Thompson was married to Shedrick Thompson for eleven years. She is buried at Mount Morris Community Cemetery. *Author's collection.*

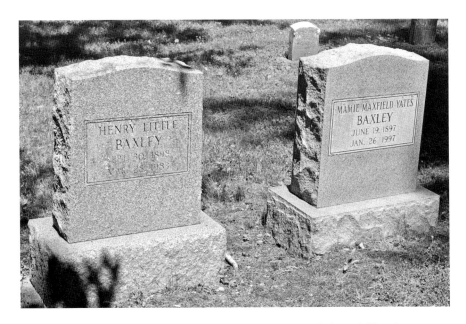

Henry and Mamie Baxley are buried in the graveyard at Leeds Episcopal Church near Hume. *Author's collection.*

a bank director and chairman of the county Democratic committee. His son remembered him as a skilled woodworker who created beautiful pieces, including the candleholders at Leeds Church. He was modest and

quick to smile, outgoing and dependable, and his neighbors looked to him as one of their leaders. One associate said that if someone can be both a progressive and a conservative, Henry was. He died of cancer in 1983. He was eighty-four.

Mamie Baxley, a lifelong homemaker, was haunted by what happened to her at Edenhurst. She had moved to the property as a bride in 1923, and she and Henry spent nine happy years there, including the last two as new parents after the birth of their only child. Yet after the attack, she never spent another night in the house. She died in a nursing home in Fairfax County, Virginia, in 1997. She was ninety-nine.

Notes

Chapter 1

1. Thompson's attack on the Baxleys was widely covered in the local press. Examples include *Strasburg News*, "Brutally Clubbed While Asleep in Bed," July 20, 1932, 1; *Fauquier Democrat*, "Fauquier Couple Brutally Attacked by Negro Man," 1; and *Winchester Evening Star*, "Fauquier Posse Hunts Negro Alleged to Have Attacked Man and Wife," July 1, 1932, 1. Henry Baxley Jr. also wrote about the incident in his family history, *The Cove Remembered*, 14.
2. *Strasburg News*, "Brutally Clubbed While Asleep in Bed."
3. Interviews with Alphonso Washington, conducted by Jim Hall, Warrenton, Virginia, March 11, 2013, and Hume, Virginia, September 11, 2014.
4. Interview with Henry Green, conducted by Jim Hall, Linden, Virginia, April 10, 2013. Moss was playing cards at the "Hume Country Club," the joking name he and his friends gave to the cinder block building where they met.
5. The wanted poster appeared in the *Fauquier Democrat*, July 27, 1932, 1. The grand jury report can be found in Fauquier County Law Order Book 1928, October 3, 1932, 373, Clerk's Office, Circuit Court of Fauquier County, Warrenton, Virginia.
6. *Richmond Times-Dispatch*, "Virginia Law Takes Course in Halifax Case," 31. A record of Virginia's executions can be found at http://deathpenaltyusa.org/usa1/state/virginia5.htm and at http://www.deathpenaltyinfo.org/documents/ESPYstate.pdf.
7. Prior to Pannell's electrocution, the last white man to be executed in Virginia for rape or attempted rape was John Perkins in 1868. See http://www.deathpenaltyinfo.org/documents/ESPYstate.pdf.

Chapter 2

8. Hollie, Tyler and White, *African Americans of Fauquier County*, 21.

9. *Fauquier Democrat*, "In the Town and Out in the County," July 23, 1932, 1.

10. Washington, *All in God's Time*, 19.

11. Gottmann, *Virginia at Mid-Century*, 171.

12. National Register of Historic Places, Inventory Nomination Form, Warrenton Historic District, National Park Service, Continuation Sheet 2, page 2, October 13, 1983.

13. Brown, Nicklin and Toler, *250 Years in Fauquier County*, 1.

14. U.S. Census Bureau, Fifteenth Census, 1930, Fauquier County, Virginia. Fauquier's population in 1830 was 26,086. See http://mapserver.lib.virginia.edu.

15. Ibid., County Table VIII, Land in Orchard and Subtropical Fruits. The *Fauquier Democrat* carried weekly ads about the sales at Cornblatt's and the movies at Pitts' Fauquier Theatre, June 25, 1932.

16. U.S. Census Bureau, Fifteenth Census, 1930, Fauquier County, Virginia, 1930. The census counted 4,528 families countywide and 688 families in Fauquier with radios. In 1930, there were 1,301 residential phones. In 1929, there were 2,781 cars. Census of Electrical Industries, 1932, Telephones and Telegraphs. See http://www2.census.gov/prod2/decennial/documents/13472815_TOC.pdf and http://www.virginiadot.org/about/resources/historyofrds.pdf.

17. Kuznets, "National Income, 1929–1932," 11.

18. *Fauquier Democrat*, "No Trace of Shadrack Thompson," 1; *Strasburg News*, "Brutally Clubbed While Asleep in Bed," 1.

19. Funkhouser, Marshall and Matthews, *Black Narratives in Fauquier County*, 31.

20. The hunt for Thompson was widely covered by the local press. Some examples include *Fauquier Democrat*, "No Trace of Shadrack Thompson," 1; *Washington Post*, "Posse Trails Man Wanted in Assault," 2; *Winchester Evening Star*, "Hunt Continues in Fauquier for Attacker of Two," 1; *Martinsburg (WV) Evening Journal*, "Fugitive Negro Is Being Hunted Here," 7; *Front Royal Record*, "Was Thompson Seen Near Sperryville?," 1.

21. Interview with George Thompson, conducted by Thomas Davenport, Markham, Virginia, May 2013.

22. Interview with Melvin Poe, conducted by Jim Hall, Hume, Virginia, April 18, 2013.

23. Brundage, *Lynching in the New South*, 33.

24. Historical Census Browser, University of Virginia Library, http://mapserver.lib.virginia.edu; Schick, "Slavery in Fauquier County," 1.

25. Discussions of Fauquier's Free State can be found in *New York Times*, "What Became of the Hessians"; Herbert, *Life on a Virginia Farm*, 116;

Gott, *High in Old Virginia's Piedmont*, 50. A discussion of the Lord Fairfax land grant can be found at http://www.virginiaplaces.org/settleland/fairfaxgrant.html.

26. U.S. Census Bureau, Twelfth Census, Fifteenth Census, 1900, 1930, Fauquier County, Virginia.

27. Brundage, *Lynching in the New South*, 52.

28. Toby Keith and Scotty Emrick, "Beer for My Horses," song, 2003.

29. Interview with Henry Green, conducted by Jim Hall, Linden, Virginia, April 10, 2013.

30. In 1932, the DeButts family called their house and farm "Mt. Welby." In recent years, another owner has renamed the property "Mount Welby."

31. Interview with Jeff Urbanski, conducted by Jim Hall, Linden, Virginia, April 10, 2013.

32. Interview with Barbara Herrell, conducted by Jim Hall, Linden, Virginia, April 13, 2013.

33. Interview with Sam Poles, conducted by Jim Hall, Hume, Virginia, July 24, 2015.

34. *Strasburg News*, "Brutally Clubbed While Asleep in Bed," 1.

35. Interview with Reverend Allen Baltimore, conducted by Thomas Davenport, Front Royal, Virginia, July 31, 2013.

36. *Front Royal Record*, "Protests Methods of Thompson Posse," 1.

37. Funkhouser, Marshall and Matthews, *Black Narratives in Fauquier County*, 31.

38. *Fauquier Democrat*, "In the Town and Out in the County," July 27, 1932, 5.

Chapter 3

39. Harry F. Byrd to Henry Baxley, July 20, 1932.

40. Henry Baxley to Harry F. Byrd, July 24, 1932; *Fauquier Democrat*, "Hospital Notes," 1.

41. Henry Baxley to Harry F. Byrd, July 20, 1932.

42. Interview with Barbara Herrell, conducted by Jim Hall, Linden, Virginia, August 8, 2014.

43. Baxley, *Cove Remembered*, 14.

44. Ibid., 28.

45. Interview with Henry Baxley Jr., conducted by Thomas Davenport, Marshall, Virginia, December 2012.

46. *Fauquier Democrat*, "Fauquier Couple Brutally Attacked by Negro Man," 1.

47. Baxley, *Cove Remembered*, 20.

48. Fauquier County Bicentennial Committee, *Fauquier County, Virginia*, 124.

49. Baxley, *Cove Remembered*, 13.

50. Ibid., 13.

51. *Fauquier Democrat*, "Miss Maxfield Yates Weds Henry Baxley," 1.
52. Baxley, *Cove Remembered*, 15.

Chapter 4

53. William Schill to C.W. Carter, July 21, 1932.
54. *Fauquier Democrat*, "$250 Reward," July 27, 1932, 1.
55. One of the puzzling aspects of this story is how often Shedrick Thompson's name was misspelled. Thompson was born in Fauquier County to a Fauquier family. He spent most of his life in the county, married a Fauquier County woman and worked for his neighbors on their farms and in their orchards. Yet after he attacked the Baxleys, when he became the object of an intense manhunt, no one seemed to know his name. In newspaper stories and legal papers, his first name appears at least nine different ways. Because the errors are so numerous, I decided not to change or call attention to them. Instead, the quotations appear as they did in the originals. Official documents, including his 1917 draft registration form and his 1921 marriage license, are definitive. Thompson's first name was Shedrick.
56. *Fauquier Democrat*, "$250 Reward," July 20, 1932, 5; July 23, 1932, 4; July 27, 1932, 1.
57. Interview with Sylvia Gaskins, conducted by Jim Hall, Fredericksburg, Virginia, January 5, 2002.
58. U.S. Census Bureau, Twelfth Census, 1900; Thirteenth Census, 1910; Fourteenth Census, 1920; Fifteenth Census, 1930, Fauquier County, Virginia; Thompson family graves, Mount Morris Community Cemetery, Hume, Virginia.
59. Interview with Alex Green, conducted by Thomas Davenport, Markham, Virginia, 2009.
60. Washington, *All in God's Time*, 54.
61. Toler, "Fauquier County in World War I."
62. Gaskins, *Fauquier County in War Time.*
63. Records of Shedrick Thompson, U.S. Army serial no. 3839793, National Personnel Records Center, St. Louis, Missouri; Robert J. Dalessandro e-mail to Jim Hall, April 29, 2013.
64. Schmidt, *American Voices of World War I*, 70.
65. *Arkansas Gazette*, "Hungry Negro Is Cause of Trouble," 1; *Columbia Banner*, "Negro Soldier Starts Near Riot," 1.
66. Whitaker, *On the Laps of Gods*, 105, 321. Stockley, *Blood in Their Eyes*, xxiii; Cortner, *Mob Intent on Death*, 5. Winthrop Rockefeller Foundation, "The Elaine Race Riot: Part 1," video, https://www.youtube.com/watch?v=EM7XTg2tSDo.

67. National Personnel Records Center, St. Louis, Missouri.
68. Roshnavand and Torghabeh, "African Americans and the Reconceptualization of Identity," 37.
69. Du Bois, "Returning Soldier," 13.
70. National Personnel Records Center, St. Louis, Missouri.
71. Interview with Sylvia Gaskins, conducted by Jim Hall, Warrenton, Virginia, April 18, 2013.
72. Interview with Reverend Lindsay Green, conducted by Jim Hall, Hume, Virginia, July 24, 2015.
73. Funkhouser, Marshall and Matthews, *Black Narratives in Fauquier County.*
74. Interview with Reverend William Gibbs, conducted by Jim Hall, Dale City, Virginia, August 5, 2014.
75. Funkhouser, Marshall and Matthews, *Black Narratives in Fauquier County*.
76. *Chicago Defender*, "Mob Cuts Man's Body from Tree, Burns It," 13; *Fauquier Democrat*, "Fauquier Couple Brutally Attacked by Negro Man," 1.
77. Marriage license, Prince William County, Virginia, March 18, 1921, Clerk's Office, Circuit Court of Prince William County, Manassas, Virginia; interview with Sylvia Gaskins, conducted by Jim Hall, Warrenton, Virginia, April 18, 2013.
78. Interview with Elsie McCarty, conducted by Thomas Davenport, Delaplane, Virginia, December 9, 1994.
79. *Winchester Evening Star*, "Hunt Continues in Fauquier for Attacker of Two," 1.
80. *Front Royal Record*, "Brutally Clubbed While Asleep in Bed," 1.
81. Ibid.
82. Interview with Sylvia Gaskins, conducted by Jim Hall, Warrenton, Virginia, April 18, 2013.
83. Interview with Carol Scott, conducted by Jim Hall, Markham, Virginia, August 13, 2014.
84. Interview with Reverend Allen Baltimore, conducted by Thomas Davenport, Front Royal, Virginia, July 31, 2013.

Chapter 5

85. *Fauquier Democrat*, "No Trace Found of Shadrack Thompson," July 23, 1932, 1.
86. Harry F. Byrd to Governor John Garland Pollard, September 15, 1932.
87. Pollard Executive Papers, folder "Lynching," Box 86, Library of Virginia, Richmond, Virginia, September 16, 1932.
88. Henry Baxley to Harry F. Byrd, September 16, 1932.
89. Kenney's discovery of Thompson's body and the events that followed

were front-page news in the local press. Examples include *Winchester Evening Star*, "Attacker of Two Is Found Hanging; and Body Burned," 1; *Winchester Star*, "Body of Negro Charged with Criminal Assault Found Hanging to Tree," 1; *Fauquier Democrat*, "Body of Shadrack Thompson Found," 1; *Northern Virginia Daily*, "Fauquier Mob Burns Body of Negro Who Attacked Baxleys," 1; *Richmond News Leader*, "Body of Attack Suspect Found," 1; *Blue Ridge Guide*, "Crowd Burns Negro's Body," 1.

90. Interview with Chaz Greene, conducted by Jim Hall, Linden, Virginia, July 24, 2015.

91. *Harrisonburg (VA) Daily News Record*, "Denies Negro Was Tortured, Lynched," 1.

92. Interview with Jeff Urbanski, conducted by Jim Hall, Linden, Virginia, April 10, 2013.

93. *Richmond News Leader*, "Find Va. Lynching Stories Baseless," 1.

94. *Chicago Defender*, "Mob Cuts Man's Body from Tree, Burns It," 13.

95. Interview with Bunny Nash, conducted by Thomas Davenport, Warrenton, Virginia, March 2015.

96. Noah Kenney to Fauquier County Board of Supervisors, September 24, 1932.

97. Walter Olmstead to T.E. Bartenstein, May 26, 1933.

98. *Northern Virginia Daily*, "County Coroner Reiterates His Verdict," 1.

99. *Fauquier Democrat*, "In Town and Out in the County," November 2, 1932, 1.

100. Law Order Book 1928T, 358, Clerk's Office, Circuit Court of Fauquier County, Warrenton, Virginia.

101. *Northern Virginia Daily*, "County Coroner Reiterates His Verdict." Davis's insistence that Thompson's hands would have been tied if he had been lynched is contradicted by the photos of lynch victims whose hands and feet were not bound. Several examples can be found in Allen, Als, Lewis and Litwack, *Without Sanctuary*.

102. *Richmond News Leader*, "Find Va. Lynching Stories Baseless," 1.

CHAPTER 6

103. *Northern Virginia Daily*, "County Coroner Reiterates His Verdict," 1.

104. *Washington Evening Star*, "Suicide Doubted in Death of Man," 1.

105. *Richmond News Leader*, "Was It a Lynching?," 8.

106. *Norfolk (VA) Journal and Guide*, "If This Is a Suicide, What's a Lynching?," 1.

107. *Chicago Defender*, "Suicide Is Now Synonymous with Lynching in Va.," 13.

108. *Northern Virginia Daily*, "Strange Birds," 4.

109. *Martinsburg (WV) Evening Journal*, "Suicide Doubted in Negro's Hanging," 3.

110. *Lowell (MA) Courier-Citizen*, "Lynching in Private?"

111. *Winchester Evening Star*, "Attacker of Two Is Found Hanging; and Body Burned," 1; *Northern Virginia Daily*, "Fauquier Mob Burns Body of Negro Who Attacked Baxleys," 1; *Warren Sentinel*, "Crowd Burns Negro's Body," 1; *Fauquier Democrat*, "Body of Shadrack Thompson Found," 1.

112. *Fauquier Democrat*, "In Town and Out in the County," September 21, 1932, 1.

113. Law Order Book 1928, 373, October 3, 1932, Clerk's Office, Circuit Court of Fauquier County, Warrenton, Virginia.

114. Chadbourn, *Lynching and the Law*, 13.

115. Lindquist-Dorr, *White Women, Rape, and the Power of Race*, 30.

116. Raper, *Mob Still Rides*, 11.

117. Roy Flannagan to Walter White, February 3, 1933.

118. Flannagan, *County Court*, 9.

119. *Richmond News Leader*, "Find Va. Lynching Stories Baseless," 1.

120. *New York Times*, "Crime and Disaster," 6.

121. The organizations' 1932 lists of lynch victims were widely reported. Articles included *New York Times*, "Lynchings at New Low," 16; *New York Times*, "Eleven Lynchings This Year," 3; "Organizations Disagree on 1932 Lynching Number," January 6, 1933; news clippings file, the Tuskegee Institute, Reel 227; *Associated Negro Press*, "What Is a Lynching?"; *Baltimore Afro-American*, "All Lynchings Not Reported, League Asserts."

122. *Chattanooga Times*, "Must Alter View to End Mob Law, Milton Declares."

123. Harry Byrd to George Milton, December 29, 1932.

124. Harry Byrd to Louis Jaffe, December 29, 1932.

125. Harry Byrd to Walter White, January 23, 1933.

126. *Richmond Times-Dispatch*, "Southern Progress and Reaction in 1932."

127. The Bird lynching was widely covered by newspapers throughout the state. Examples included *Richmond Times-Dispatch*, "Masked Mob Storms Jail, Kills Negro," 1; *Richmond News Leader*, "Governor Regrets Negro's Lynching in Wythe County," 1; *Roanoke World-News*, "Deplores Wytheville Lynching," 1; *Richmond News Leader*, "Dark Disgrace to Virginia," 8; *Richmond Times-Dispatch*, "Law and Order Outraged," 6; *Richmond Times-Dispatch*, "Jury Quickly Frees Willard in Mob Killing." More recent coverage includes Beers, "Wythe County Lynching of Raymond Bird," 34.

128. Press coverage of the lynching of Leonard Woods included *Richmond Times-Dispatch*, "Byrd Condemns Negro Hanging as 'Dastardly,'" 1; *Richmond Times-Dispatch*, "Uncle Sam Busy in Lynching Probe," 1; *Richmond News Leader*, "Mob Takes Life of Negro Held as Va. Man's Slayer," 1.

129. Harry F. Byrd to Walter White, January 23, 1933; Smith, "Anti-Lynching Law of 1928."

130. Harry Byrd to George Milton, December 29, 1932.

131. *Richmond Times-Dispatch*, "Lynchings Must Stop, Declares Governor," 4.
132. Heinemann, *Harry Byrd of Virginia*, 145.
133. Walter White to Douglas Freeman, January 11, 1933.
134. Walter White to George Milton, January 11, 1933.
135. Walter White to Harry F. Byrd, January 24, 1933.
136. James H. Dillard to Walter White, January 25, 1933, and February 17, 1933.
137. National Association for the Advancement of Colored People, *Twenty-third Annual Report*, 33.
138. *Richmond News Leader*, "Tuskegee Makes Inquiries About Thompson Case," 2.
139. Work, "Lynching Record, 1932."

CHAPTER 7

140. Brundage, *Lynching in the New South*, 281.
141. Tolnay and Beck, *Festival of Violence*, 271; Brundage, *Lynching in the New South*, 281. Tolnay and Beck trace a continuous decline in the annual rate of lynch deaths for ten southern states, beginning in 1900. Brundage also shows a decline in the annual rate for Virginia, beginning in 1900, but that trend reverses beginning in 1917.
142. National Association for the Advancement of Colored People, *Thirty Years of Lynchings in the United States*, 39.
143. Tolnay and Beck, *Festival of Violence*, 272. The authors count 2,805 lynch victims, including 2,462 blacks, killed from 1882 to 1930 in ten southern states.
144. Equal Justice Initiative, *Lynching in America*, 5.
145. Lewis, *W.E.B. Du Bois*, 231.
146. Tolnay and Beck, *Festival of Violence*, 260.
147. Ibid., 47.
148. Davis, "Not Only War Is Hell," 477.
149. Tolnay and Beck, *Festival of Violence*, 50.
150. Patterson, *Rituals of Blood*, 173.
151. NAACP, 32.
152. Brundage, *Lynching in the New South*, 263.
153. Ibid., 180.
154. Ibid., 281. Virginia had 134 localities in the census of 1930. Forty-eight localities experienced a lynching. Nineteen of them had two or more lynchings.
155. *Richmond Dispatch*, "Negro Lynched," 3.
156. Zangrando, *NAACP Crusade Against Lynching*, 8.
157. *Fredericksburg (VA) Free Lance*, "Trial of Dye," 3.

158. Ibid., "Lynching Was Feared," 1.
159. Ibid.
160. Ibid., "Trial of Heflin," 1.
161. Ibid., "Swifter than the Law," 3.
162. Rumph, "Last Mob Lynching in Fauquier County," 15
163. Jeffries, *Joseph Arthur Jeffries' Fauquier County*, 185.

Chapter 8

164. Dray, *At the Hands of Persons Unknown*, 382.
165. *Baltimore Afro-American*, "All Lynchings Not Reported, League Asserts."
166. Abel Meeropol, "Strange Fruit," song, 1937.
167. Dabney, "Dixie Rejects Lynching," 579.
168. Brundage, *Lynching in the New South*, 189.
169. Beers, "Wythe County Lynching of Raymond Bird," 34.
170. Rumph, "Last Mob Lynching in Fauquier County," 11.
171. Smith, *Managing White Supremacy*, 184.
172. Lindquist-Dorr, *White Women, Rape, and the Power of Race*, 30.
173. Heinemann, *Harry Byrd of Virginia*, 80.
174. Ronald L. Heinemann to Jim Hall, e-mail, February 14, 2002.
175. Charles Perdue to Jim Hall, e-mail, March 14, 2002.
176. Raper, *Mob Still Rides*, 5.
177. Ibid., 24.
178. *Richmond Planet*, "Was It a Lynching?," 12.
179. Interview with Alphonso Washington, conducted by Jim Hall, Warenton, Virginia, March 11, 2013.
180. Ames, *Changing Character of Lynching*, 28.
181. Interview with Jeff Urbanksi, conducted by Jim Hall, Linden, Virginia, April 10, 2013.
182. Ibid., August 8, 2014.
183. Interview with Henry Baxley Jr., conducted by Jim Hall, Marshall, Virginia, December 2012.
184. Interview with Jeff Urbanski, conducted by Jim Hall, Fredericksburg, Virginia, August 14, 2014.
185. Interview with Sylvia Gaskins, conducted by Jim Hall, Warrenton, Virginia, April 18, 2013.
186. Interview with Barbara Herrell, conducted by Thomas Davenport, Linden, Virginia, April 13, 2013.
187. Interview with Emma Coleman, conducted by Thomas Davenport, Markham, Virginia, 1997. Coleman was one hundred years old when interviewed.

188. Interview with Jeff Urbanski, conducted by Jim Hall, Linden, Virginia, April 10, 2013.

189. Interview with Doug Hume, conducted by Thomas Davenport, Markham, Virginia, September 17, 2014.

190. *Richmond News Leader*, "Find Va. Lynching Stories Baseless," 1.

191. *Clifton Forge Review*, "Looks Like Lynching."

192. Interview with Reverend William Gibbs, conducted by Jim Hall, Dale City, Virginia, August 5, 2014.

193. Interview with Jeff Urbanski, conducted by Jim Hall, Linden, Virginia, April 10, 2013.

BIBLIOGRAPHY

ARTICLES

Beers, Paul G. "The Wythe County Lynching of Raymond Bird: Progressivism vs. Mob Violence in the 1920s." *Appalachian Journal* (Fall 1994): 34.

Dabney, Virginius. "Dixie Rejects Lynching." *Nation* (November 27, 1937).

Davis, David A. "Not Only War Is Hell: World War I and African-American Lynch Narratives." *African-American Review* (Fall/Winter 2008): 477.

Du Bois, W.E.B. "The Returning Soldier." *The Crisis* (May 1919).

Funkhouser, Celina, Richard Marshall and Jim Matthews. "Black Narratives in Fauquier County." *Anthropology* 147 (1973): 31. University of Virginia, Library Accession no. 10493, Box 8.

Kuznets, Simon. "National Income, 1929–1932." National Bureau of Economic Research, June 1934.

Roshnavand, Farshid Nowrouzi, and Rajabali Askarzadeh Torghabeh. "African Americans and the Reconceptualization of Identity: Black Participation in World War I and the Rise of the New Negro Consciousness." *Khazar Journal of Humanities and Social Sciences* 16 (2013): 37.

Rumph, Marylin. "The Last Mob Lynching in Fauquier County." *Fauquier* (Spring 1994).

Schick, Kurt. "Slavery in Fauquier County." *News and Notes from the Fauquier Historical Society* (Fall 1983).

Smith, J. Douglas Smith. "Anti-Lynching Law of 1928." Encyclopedia of Virginia. http://www.encyclopediavirginia.org/Antilynching_Law_of_1928#start_entry.

Toler, John T. "Fauquier County in World War I." *News and Notes from the Fauquier Historical Society* (Fall-Winter 1993).

Work, Monroe N., comp. "Lynching Record, 1932." Department of Records and Research, Tuskegee Institute, Alabama.

BOOKS

Allen, James, Hilton Als, Congressman John Lewis and Leon F. Litwack. *Without Sanctuary: Lynching Photography in America.* Santa Fe, NM: Twin Palms Publishers, 2000.

Ames, Jessie Daniel. *The Changing Character of Lynching: Review of Lynching, 1931–1941.* Atlanta, GA: Commission on Interracial Cooperation, 1942.

Baxley, Henry, Jr. *The Cove Remembered.* Fauquier, VA: self-published, 2000.

Brown, Kathi Ann, Walter Nicklin, and John T. Toler. *250 Years in Fauquier County: A Virginia Story.* Fairfax, VA: GMU Press, 2008.

Brundage, W. Fitzhugh. *Lynching in the New South: Georgia and Virginia, 1880–1930.* Urbana: University of Illinois Press, 1993.

Chadbourn, James H. *Lynching and the Law.* Chapel Hill: University of North Carolina Press, 1933.

Cortner, Richard C. *A Mob Intent on Death: The NAACP and the Arkansas Riot Cases.* Middletown, CT: Wesleyan University Press, 1988.

Dray, Philip. *At the Hands of Persons Unknown: The Lynching of Black America.* New York: Random House, 2002.

Equal Justice Initiative. *Lynching in America: Confronting the Legacy of Racial Terror.* Montgomery, AL: Equal Justice Initiative, 2015.

Fauquier County Bicentennial Committee. *Fauquier County, Virginia, 1759–1959.* Warrenton: Virginia Publishing, 1959.

Flannagan, Roy. *County Court.* New York, Doubleday, Doran & Company, 1937.

Gaskins, Meta. *Fauquier County in War Time.* Fauquier, VA: self-published, 1925.

Gott, John K. *High in Old Virginia's Piedmont: A History of Marshall (Formerly Salem).* Marshall, VA: Marshall National Bank & Trust, 1987.

Gottmann, Jean. *Virginia at Mid-Century.* New York: Henry Holt and Company, 1955.

Heinemann, Ronald L. *Harry Byrd of Virginia.* Charlottesville: University of Virginia Press, 1996.

Herbert, Robert Beverley. *Life on a Virginia Farm: Stories and Recollections of Fauquier County.* Warrenton, VA: Fauquier Democrat, 1968.

Hollie, Donna Tyler, Brett M. Tyler and Karen Hughes White. *African Americans of Fauquier County.* Charleston, SC: Arcadia Publishing, 2009.

Jeffries, Joseph Arthur. *Joseph Arthur Jeffries' Fauquier County, Virginia, 1840–1919.* Edited by Helen Jeffries Klitch. Fauquier, VA: P. Bate Associates, 1989.

Lewis, David Levering. *W.E.B. Du Bois, a Reader*. New York: Henry Holt and Company, 1995.

Lindquist-Dorr, Lisa. *White Women, Rape, and the Power of Race in Virginia, 1900–1960*. Chapel Hill: University of North Carolina Press, 2004.

National Association for the Advancement of Colored People. *Thirty Years of Lynchings in the United States: 1889–1918*. New York: self-published, 1919.

———. *Twenty-third Annual Report, 1932*. New York: self-published, 1933.

Patterson, Orlando. *Rituals of Blood*. Washington, D.C.: Civitas/ Counterpoint, 1998.

Raper, Arthur F. *The Mob Still Rides*. Atlanta, GA: Commission on Interracial Cooperation, 1936.

Schmidt, Lieutenant Ludwig. *American Voices of World War I: Primary Source Documents, 1917–1920*. Edited by Martin Marix Evans. New York: Routledge, 2001.

Smith, J. Douglas. *Managing White Supremacy: Race, Politics, and Citizenship in Jim Crow Virginia*. Chapel Hill: University of North Carolina Press, 2002.

Stockley, Grif. *Blood in Their Eyes: The Elaine Race Massacres of 1919*. Fayetteville: University of Arkansas Press, 2001.

Tolnay, Stewart E., and E.M. Beck. *A Festival of Violence: An Analysis of Southern Lynchings, 1882–1930*. Urbana: University of Illinois Press, 1995.

Washington, Alphonso. *All in God's Time: Memoirs from My Life's Journey*. Bloomington, IN: Xlibris Corporation, 2009.

Whitaker, Robert. *On the Laps of Gods: The Red Summer of 1919 and the Struggle for Justice that Remade a Nation*. New York: Crown Publishers, 2008.

Zangrando, Robert L. *The NAACP Crusade Against Lynching, 1909–1950*. Philadelphia, PA: Temple University Press, 1980.

CORRESPONDENCE

Baxley, Henry, to Harry F. Byrd, July 20, 1932. Papers of Harry Flood Byrd, 1911–65. University of Virginia Library, Charlottesville, Virginia.

Baxley, Henry, to Harry F. Byrd, July 24, 1932. Papers of Harry Flood Byrd, 1911–65. University of Virginia Library, Charlottesville, Virginia.

Baxley, Henry to Harry F. Byrd, September 16, 1932. Papers of Harry Flood Byrd, 1911–65. University of Virginia Library, Charlottesville, Virginia.

Baxley, Henry, to John Garland Pollard, September 16, 1932. Pollard Executive Papers. Library of Virginia, Richmond, Virginia.

Byrd, Harry F., to George Milton, December 29, 1932. Papers of Harry Flood Byrd, 1911–65. The University of Virginia Library, Charlottesville, Virginia.

Byrd, Harry F., to Governor John Garland Pollard, September 15, 1932. Pollard Executive Papers. Library of Virginia, Richmond, Virginia.

Byrd, Harry F., to Henry Baxley, July 20, 1932. Papers of Harry Flood Byrd, 1911–65. University of Virginia Library, Charlottesville, Virginia.

Byrd, Harry F., to Louis Jaffe, December 29, 1932. Papers of Harry Flood Byrd, 1911–65. University of Virginia Library, Charlottesville, Virginia.

Byrd, Harry F., to Walter White, January 23, 1933. Papers of the NAACP. Part 7. The Anti-Lynching Campaign, 1912–55. Series A, Reel 19.

Dalessandro, Robert J., to the author, April 29, 2013.

Dillard, James H., to Walter White, January 25, 1933. February 17, 1933. Papers of the NAACP. Part 7. The Anti-Lynching Campaign, 1912–55. Series A, Reel 19.

Flannagan, Roy, to Walter White, February 3, 1933. Papers of the NAACP. Part 7. The Anti-Lynching Campaign, 1912–55. Series A, Reel 19.

Heinemann, Ronald L. E-mail to the author, February 14, 2002.

Kenney, Noah, to Fauquier County Board of Supervisors, September 24, 1932. Clerk's Office. Circuit Court of Fauquier County, Warrenton, Virginia.

Olmstead, Walter, to T.E. Bartenstein, May 26, 1933. Clerk's Office. Circuit Court of Fauquier County, Warrenton, Virginia.

Perdue, Charles. E-mail to the author. March 14, 2002.

Schill, William, to C.W. Carter, July 21, 1932. Clerk's Office. Circuit Court of Fauquier County, Warrenton, Virginia.

White, Walter, to Douglas Freeman, January 11, 1933. Papers of the NAACP. Part 7. The Anti-Lynching Campaign, 1912–55. Series A, Reel 19.

White, Walter, to George Milton, January 11, 1933. Papers of the NAACP. Part 7. The Anti-Lynching Campaign, 1912–55. Series A, Reel 19.

White, Walter, to Harry F. Byrd, January 24, 1933. Papers of the NAACP. Part 7. The Anti-Lynching Campaign, 1912–55. Series A, Reel 19.

NEWSPAPERS

Arkansas Gazette. "Hungry Negro Is Cause of Trouble." February 27, 1918.

Associated Negro Press. "What Is a Lynching?" December 31, 1932.

Baltimore Afro-American. "All Lynchings Not Reported, League Asserts." December 24, 1932.

Blue Ridge (VA) Guide. "Crowd Burns Negro's Body." September 23, 1932.

Chattanooga Times. "Must Alter View to End Mob Law, Milton Declares." January 28, 1932.

Chicago Defender. "Mob Cuts Man's Body from Tree, Burns It." September 24, 1932.

———. "Suicide Is Now Synonymous with Lynching in Va." October 1, 1932.

Clifton Forge (VA) Review. "Looks Like Lynching." September 1932.

Columbia (AR) Banner. "Negro Soldier Starts Near Riot." March 6, 1918.

Fauquier (VA) Democrat. "Body of Shadrack Thompson Found." September 17, 1932.

———. "Fauquier Couple Brutally Attacked by Negro Man." July 20, 1932.

———. "Hospital Notes." August 3, 1932.

———. "In the Town and Out in the County." July 27, 1932.

———. "In the Town and Out in the County." July 23, 1932.

———. "In the Town and Out in the County." November 2, 1932.

———. "In the Town and Out in the County." September 21, 1932.

———. "Miss Maxfield Yates Weds Henry Baxley." June 9, 1923.

———. "No Trace of Shadrack Thompson." July 23, 1932.

———. "$250 Reward." July 20, 1932; July 23, 1932; July 27, 1932.

Fredericksburg (VA) Free Lance. "Lynching Was Feared." January 1, 1892.

———. "Swifter than the Law." March 22, 1892.

———. "Trial of Heflin." January 5, 1892.

———. "Trial of Dye." January 8, 1892.

Front Royal (VA) Record. "Brutally Clubbed While Asleep in Bed." July 20, 1932.

———. "Protests Methods of Thompson Posse." August 3, 1932.

———. "Was Thompson Seen Near Sperryville?" August 3, 1932.

Harrisonburg (VA) Daily News Record. "Denies Negro Was Tortured, Lynched." September 23, 1932.

Lowell (MA) Courier-Citizen. "Lynching in Private?" September 27, 1932.

Martinsburg (WV) Evening Journal. "Fugitive Negro Is Being Hunted Here." July 25, 1932.

———. "Suicide Doubted in Negro's Hanging." September 20, 1932.

New York Times. "Crime and Disaster." December 31, 1933.

———. "Eleven Lynchings This Year." December 28, 1932.

———. "Lynchings at New Low." February 6, 1933.

———. "What Became of the Hessians?" July 13, 1911.

Norfolk (VA) Journal and Guide. "If This Is a Suicide, What's a Lynching?" September 24, 1932.

Northern Virginia Daily. "County Coroner Reiterates His Verdict." September 21, 1932.

———. "Fauquier Mob Burns Body of Negro Who Attacked Baxleys." September 16, 1932.

———. "Strange Birds." September 19, 1932.

Richmond Dispatch. "A Negro Lynched." January 20, 1880

Richmond News Leader. "Body of Attack Suspect Found," September 16, 1932.

———. "A Dark Disgrace to Virginia." August 16, 1926.

———. "Find Va. Lynching Stories Baseless." October 7, 1932.

———. "Governor Regrets Negro's Lynching in Wythe County." August 16, 1926.

————. "Mob Takes Life of Negro Held as Va. Man's Slayer." November 30, 1927.

————. "Tuskegee Makes Inquiries About Thompson Case." October 28, 1932.

————. "Was It a Lynching?" September 20, 1932.

Richmond Planet. "Was It a Lynching?" May 25, 1935.

Richmond Times-Dispatch. "Byrd Condemns Negro Hanging as 'Dastardly.'" December 1, 1927.

————. "Jury Quickly Frees Willard in Mob Killing." July 20, 1927.

————. "Law and Order Outraged." August 17, 1926.

————. "Lynchings Must Stop, Declares Governor." January 17, 1928.

————. "Masked Mob Storms Jail, Kills Negro." August 16, 1926.

————. "Southern Progress and Reaction in 1932." January 1, 1933.

————. "Uncle Sam Busy in Lynching Probe." December 2, 1927.

————. "Virginia Law Takes Course in Halifax Case." February 7, 1932.

Roanoke World-News. "Deplores Wytheville Lynching." August 16, 1926.

Strasburg (VA) News. "Brutally Clubbed While Asleep in Bed." July 20, 1932.

Washington Evening Star. "Attacker of Two Is Found Hanging and Body Burned." September 16, 1932.

————. "Suicide Doubted in Death of Man." September 19, 1932.

Washington Post. "Posse Trails Man Wanted in Assault." July 20, 1932.

Winchester (VA) Evening Star. "Body of Negro Charged with Criminal Assault Found Hanging to Tree." September 16, 1932.

————. "Fauquier Posse Hunts Negro Alleged to Have Attacked Man and Wife." July 19, 1932.

————. "Hunt Continues in Fauquier for Attacker of Two." July 20, 1932.

INDEX

ABOUT THE AUTHOR

J im Hall was born in Washington, D.C., and grew up in Falls Church, Virginia. He received a bachelor's degree from Virginia Tech in Blacksburg, Virginia, and a master's degree from Virginia Commonwealth University in Richmond, Virginia. He lives now in Fredericksburg, Virginia. His thirty-six-year newspaper career included stints as a reporter and editor, first at the *Caroline Progress*, a weekly in Bowling Green, Virginia, and then at the *Free Lance-Star*, a daily in Fredericksburg. He retired in 2013.

Hall is the father of two sons. He is also a certified emergency medical technician. He enjoys finding a new bakery and wasting entire evenings during the summer watching Washington Nationals games.

Author's collection.